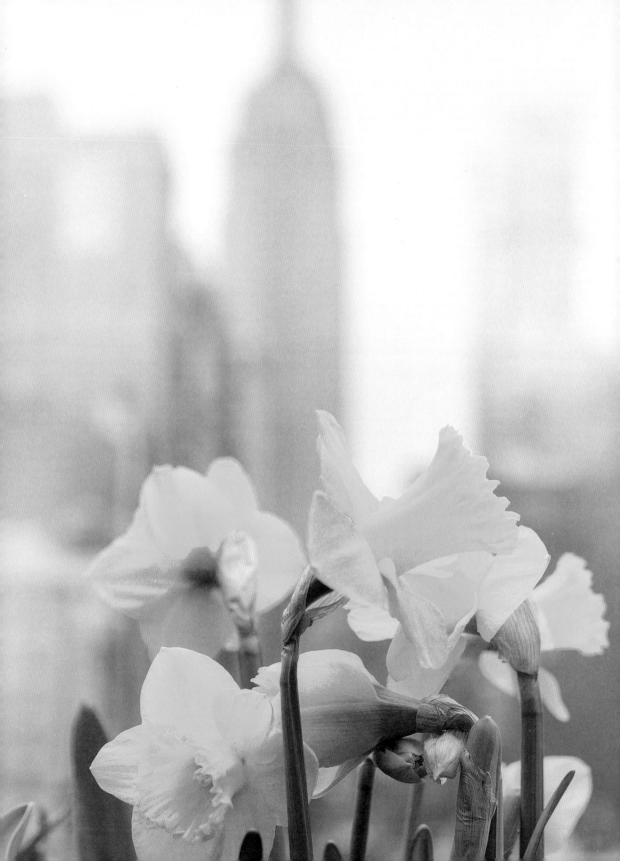

GEORGIANNA LANE

NEW YORK *in* BLOOM

ABRAMS IMAGE, NEW YORK

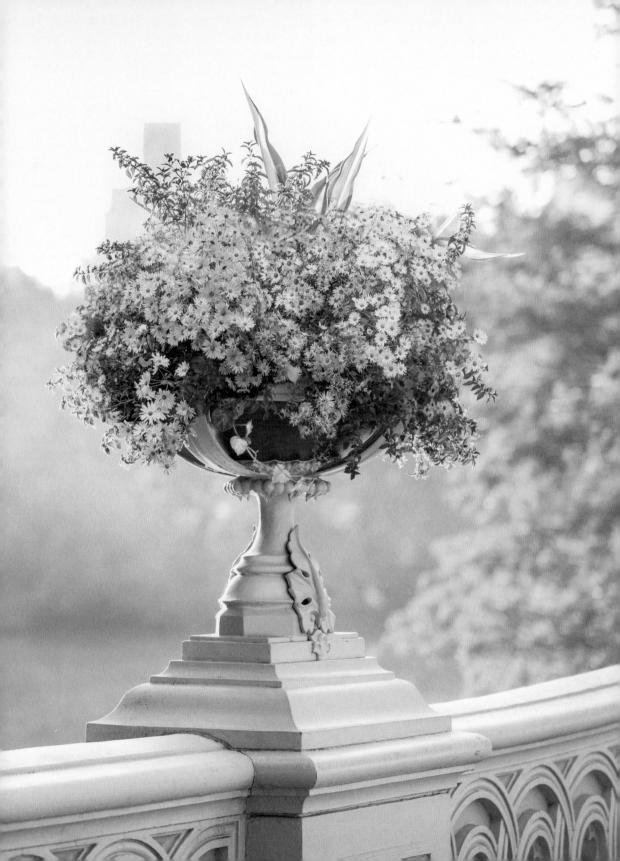

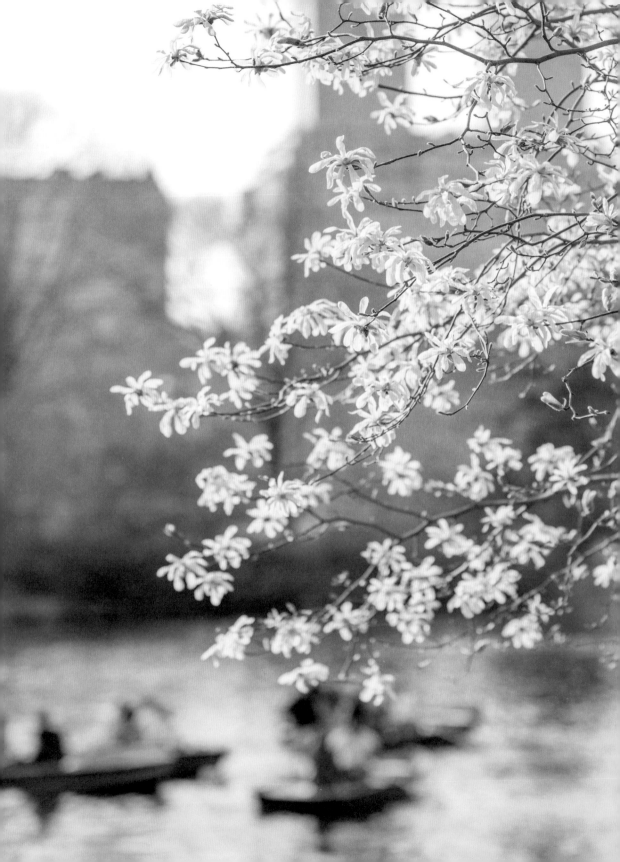

CONTENTS

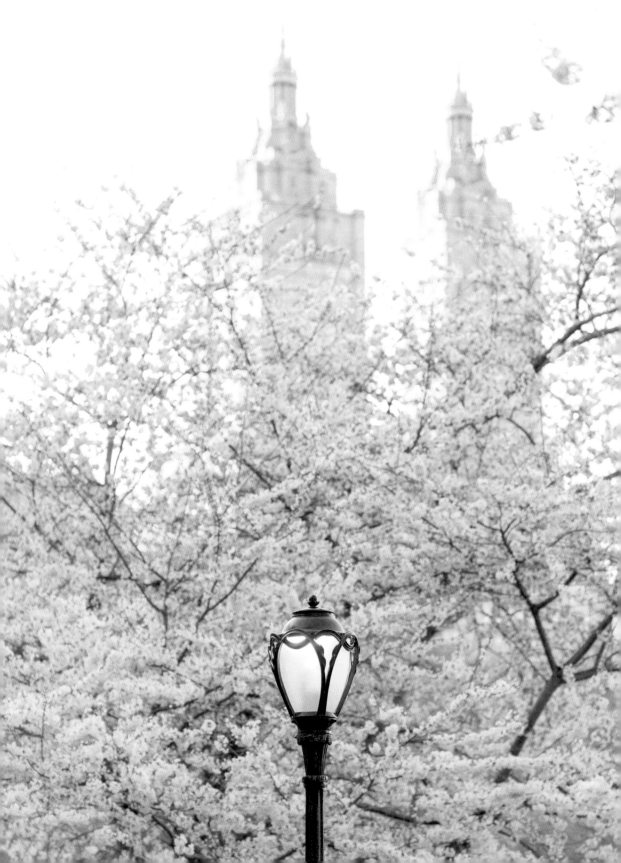

INTRODUCTION

Discovering the Floral Heart of New York City

Birdsong and daffodils. My two favorite heralds of spring.

When I recall the unusually frigid April days I spent writing and photographing the final sections of this book, those two heralds will always come to mind first. Unexpected associations, perhaps, for a work on New York City, but that, as I have well learned, is New York: unexpected, epic, bewildering, magical, exhilarating, challenging, glorious—and as many other adjectives as a thesaurus search can deliver.

My home during my quest to discover the blooming soul of New York is an apartment on East Seventy-Sixth Street, ideally located just steps from Central Park, across Fifth Avenue.

As I start out at daybreak each morning, a swelling dawn chorus rings out from the uppermost perches of trees and buildings. Robins, wrens, woodpeckers, and even owls— their symphony follows me down past the Alice in Wonderland statue and echoes around the relief sculptures of birds and plants along the steps at Bethesda Terrace. A musical chorus to inspire my own visual verses.

And though, during these first weeks of April, the city has stubbornly refused to relinquish winter, denying me the blossoming subjects of spring, I've found them meanwhile in the splendidly crafted Beaux-Arts, Art Deco, and Art Nouveau botanical architectural details of century-old skyscrapers and elegant apartment buildings. I photograph these finely crafted elements to pair with images of their real-life counterparts, my way of showing a different perspective on a city and its unique characteristics, as I did in my first book in this series, *Paris in Bloom* and the upcoming *London in Bloom*.

Gradually, with May fast approaching, New York is beginning to reveal its flowery self to me. Crocus and snowdrops have added pointillistic dots of purple and white to the

parks. Shy hellebores bow in clusters along paths. The early cherry trees are furred up with promising buds. Magnolia branches frame iconic buildings.

And everywhere—in parks and street tree beds and urns and containers—great swaths of daffodils have appeared, their nodding trumpets stalwart against the still-icy weather. Intrigued by their proliferation, I was enlightened on the poignant Daffodil Project—an undertaking of citywide planting, by residents and volunteers, of hundreds of thousands of bulbs donated annually, as a living memorial to those lost on September 11. So passionately has the project been supported that the brave, cheerful daffodil, symbolic of renewal, is now the official flower of New York City. In searching for the floral heart of New York, my own heart has been deeply touched by the golden tributes flourishing in every neighborhood.

Whether I'm photographing nature's florals or the architectural wonders inspired by them, I strive to create the definitive image of a subject, one that captures its essence for the viewer. And the fear is, especially with a place of such mythic presence, that I will fail to do it justice, that perhaps that one defining moment escaped my notice, vanishing on my periphery like the wisp of a dream.

But I've accepted that New York can never be represented by a single image, or even a series of images, and that my contribution to its story can be only what I observe through many early morning rambles and curiosity-filled wanderings, a photographic meditation seen through my own particular shade of rose-colored glasses.

As I write this, in the courtyard outside my window a family of wrens is nesting. The male's exquisite and impossibly intricate song has been my morning alarm as well as the concerto accompanying the completion of these pages. That this little virtuoso thrives in the midst of this most urban environment is a lovely miracle that has graced my days with sweetness.

So here is my humble ode to this fantastic, maddening, beautiful, demanding, ultimately rewarding, and indefinable city—a blooming tribute in words and images, composed to the heavenly notes of birdsong and illuminated by the light of the dreams of every person who calls this metropolis home.

During my quest to capture the floral essence of New York, I discovered many more reasons to fall in love with the city. May this book do the same for you.

Georgianna Lane
New York City, April 2018

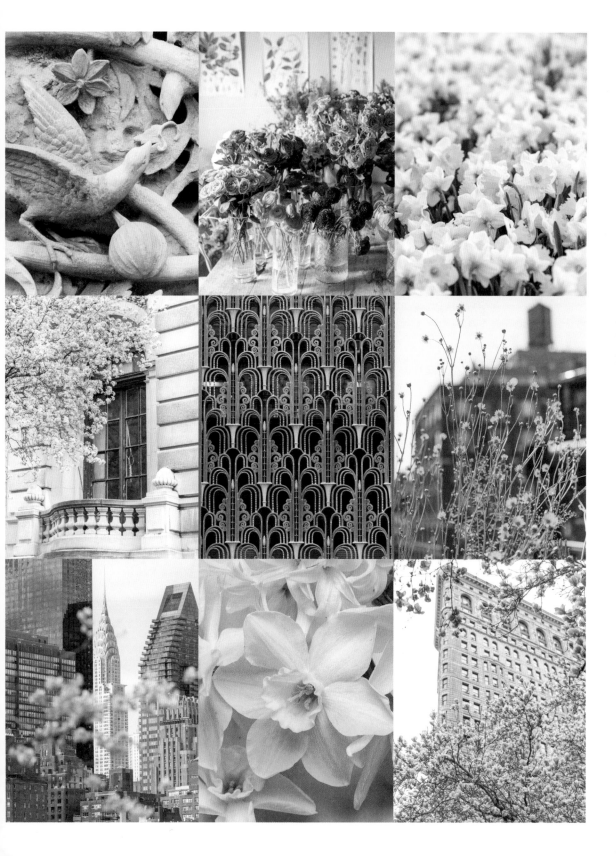

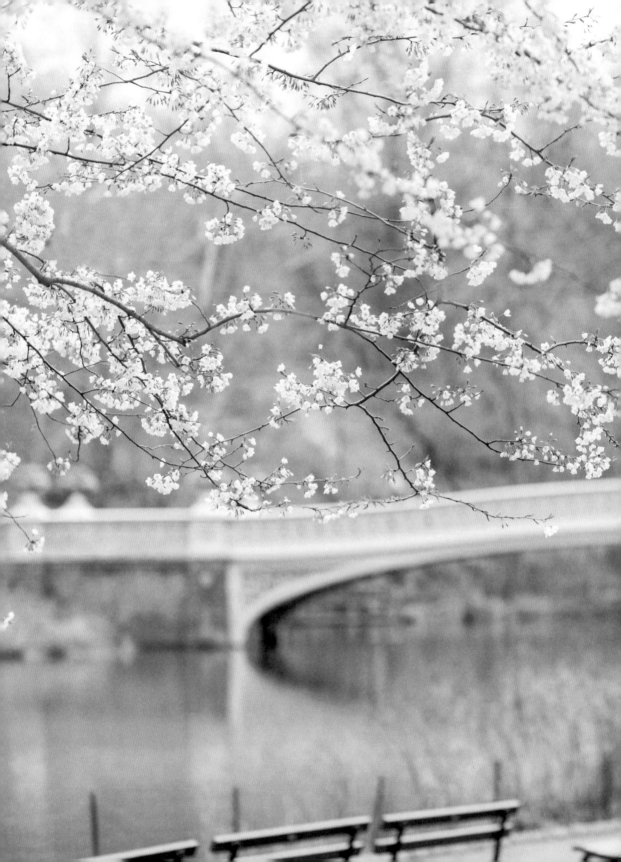

PARKS & GARDENS

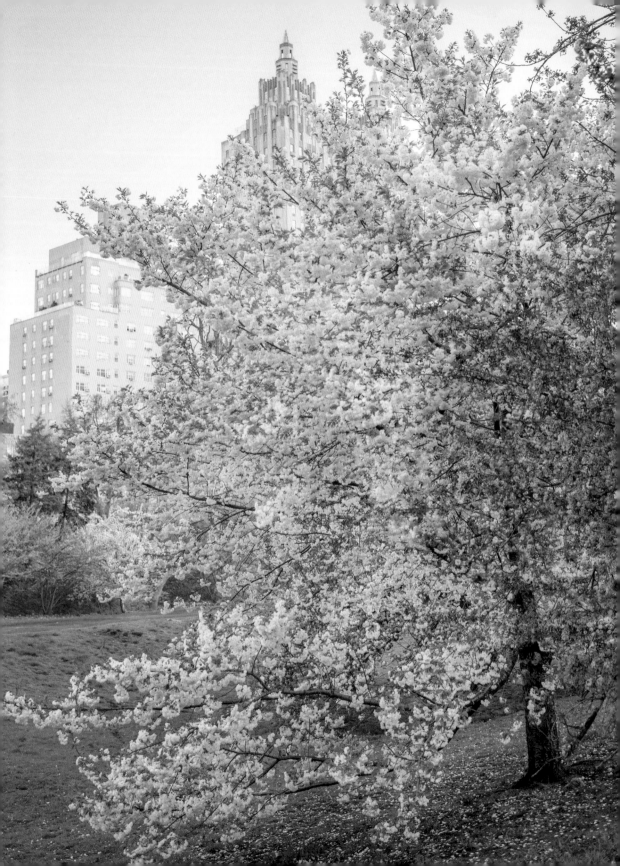

A curious anomaly of modern life is that a great city is often measured not by its glittering structures, commercial wealth, and global industry but by its devotion to celebrating and maintaining its parks and gardens.

Living close to nature, one is attuned to its cadence and emotionally calming influence. For city dwellers, however, the exhilarating and stimulating pace of life can disrupt internal rhythms and erode a sense of place in the natural world. Urbanites therefore gravitate irresistibly to the peace that open landscapes provide, becoming boaters on the Lake in Central Park or picnickers in Prospect Park, in Brooklyn.

In these natural spaces, as an antidote to rigid and right-angled habitats and workplaces, flowers are a soothing visual poem of sinuous petals, curving stems, and delicate, undulating—and more human—forms. Their evocative scents remind us of simpler days, summers in the country, and the often-missed comforts of home.

New York City's parks and gardens are astonishing marvels of scope and creativity. In abundant evidence are their caretakers' thoughtful planning, forward thinking, and passionate purpose, which evoke well-earned admiration and appreciation from New Yorkers and millions of visitors.

Among the most iconic green spaces in the world, Central Park can at once feel majestic and infinite, or comforting and intimate. If, at first, it seems vast and overwhelming, you should take the time to savor details, walk its winding paths, climb its knolls, and experience its endless magical moments. View the sunrise over the Lake as it illuminates the towers of the San Remo apartments; on a windy afternoon, feel the spray flying off the Bethesda Fountain, topped by the famous *Angel of the Waters* statue; and be amused by the darling songbirds busying about their nesting and feeding. Then this vast expanse is suddenly smaller and friendlier, like one's own backyard.

Immaculately maintained with a sensitivity for the aesthetic, muddy paths are cleared immediately, but romantic drifts of fallen cherry petals are allowed to lie undisturbed, adding a dusting of enchantment to late April views.

Spring's arrival tantalizes with the sweetest surprises. After a winter of lingering darkness and icy winds, woodland plants, such as hellebores and snowdrops, emerge to the chirping and whinnying of the thousands of cheery robins that have the run of the park. A profusion of the city's signature daffodils, those bright and brave trumpeters of the changing season, is cause for residents to breathe a collective sigh of relief in anticipation of long, relaxed days of warmth. Flowering star and saucer magnolias and Yoshino and Kwanzan cherry trees provide airy plumes of white and pale pink that invite closer inspection.

Each of New York's public green spaces has its own character, but Bryant Park, adjacent to the main branch of the New York Public Library and ringed by Midtown's high-rises, may be the most gracious and elegant. French in atmosphere and demeanor due to its symmetrical layout, generous distribution of Parisian bistro–style tables and chairs, and beautiful Le Carrousel (which revolves to French cabaret music), it provides a calming haven for visitors, local office workers, and residents. At its recently installed apiary, you can learn about honeybees and sample honey made right there in the park.

For a true escape, a short train ride from Grand Central Terminal brings you to the New York Botanical Garden, in the Bronx, which is a National Historic Landmark. Visit in spring, when the fragrant Daffodil Hill is alive with hundreds of thousands of blooms, shaded by flowering crab apples and cherry trees. Early summer is the peak for the nearly seven hundred varieties of roses at the Peggy Rockefeller Rose Garden, a sea of perfumed loveliness punctuated by a gazebo and fences, all festooned with climbers and ramblers.

In June at the Brooklyn Botanic Garden, roses similarly steal the show, following April's exuberant Sakura Matsuri festival celebrating the garden's more than two hundred flowering cherry trees.

In an urban park or garden, you can get to know a city, and you can also get to know yourself. Away from the jangling cacophony, an inner peacefulness can be found, a recharging of energy as a bolster against the emotional jostling of city life.

Thus, a New York park has far wider reaching effects than as a temporary, occasional respite. It transcends its exceptional physical appeal and becomes an invigorating, addictive tonic that calms the soul, rejuvenates the mind, and inspires wondrous dreams as lofty as the city itself.

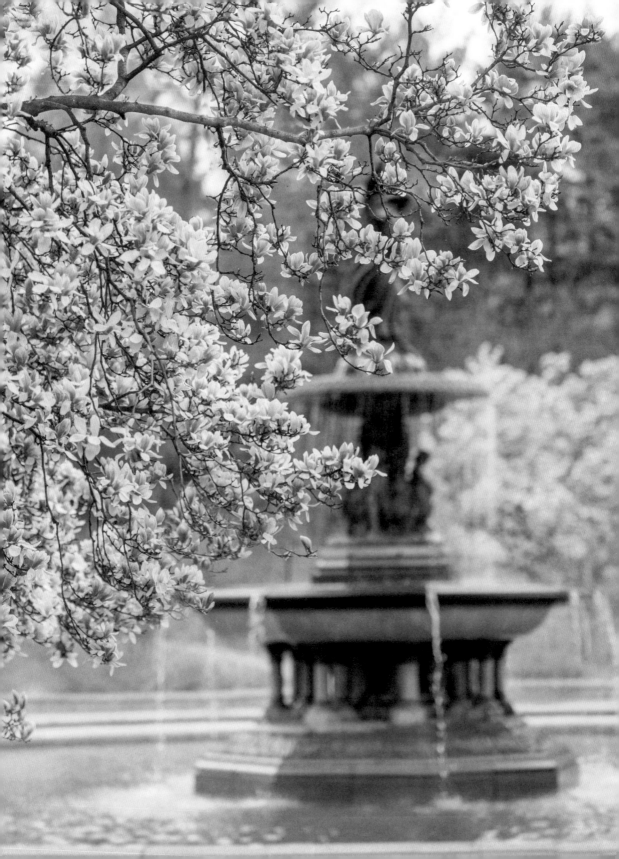

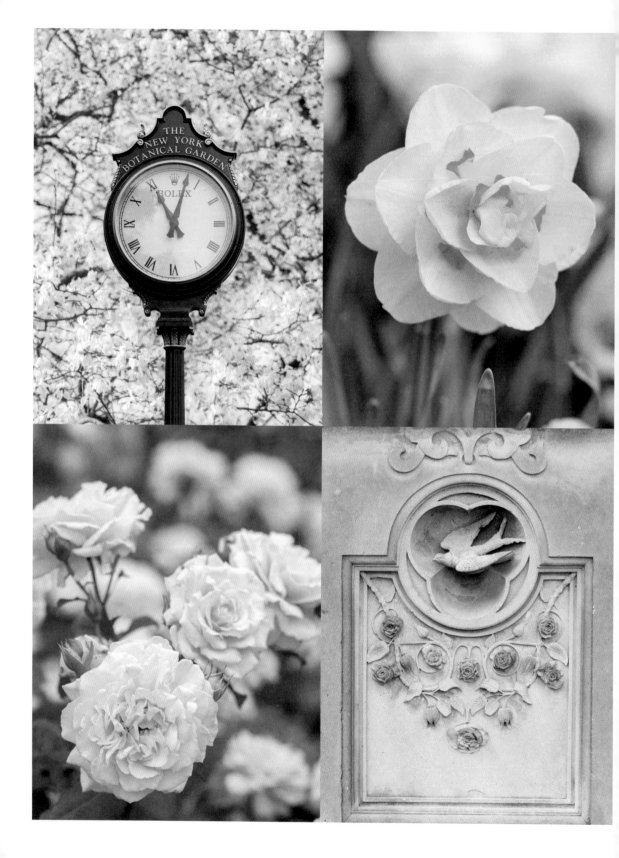

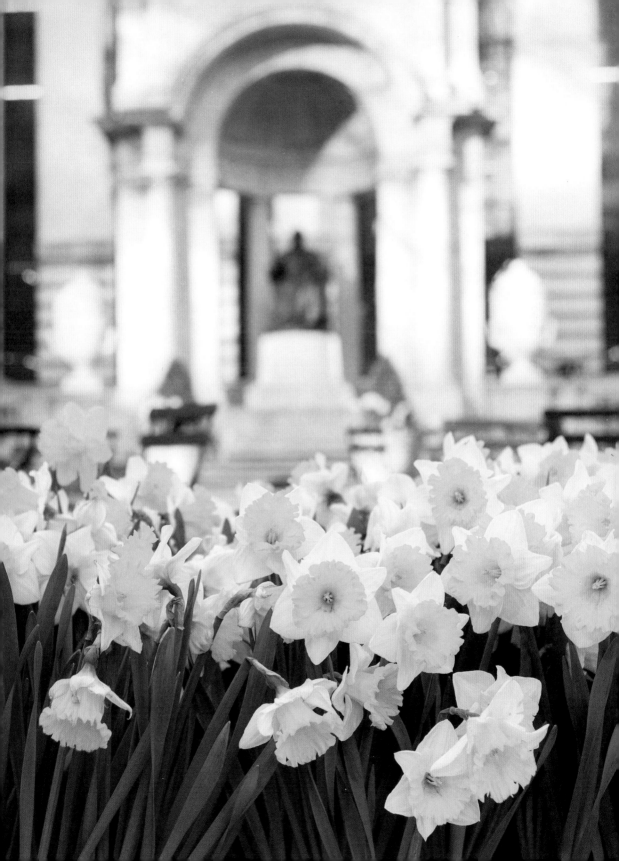

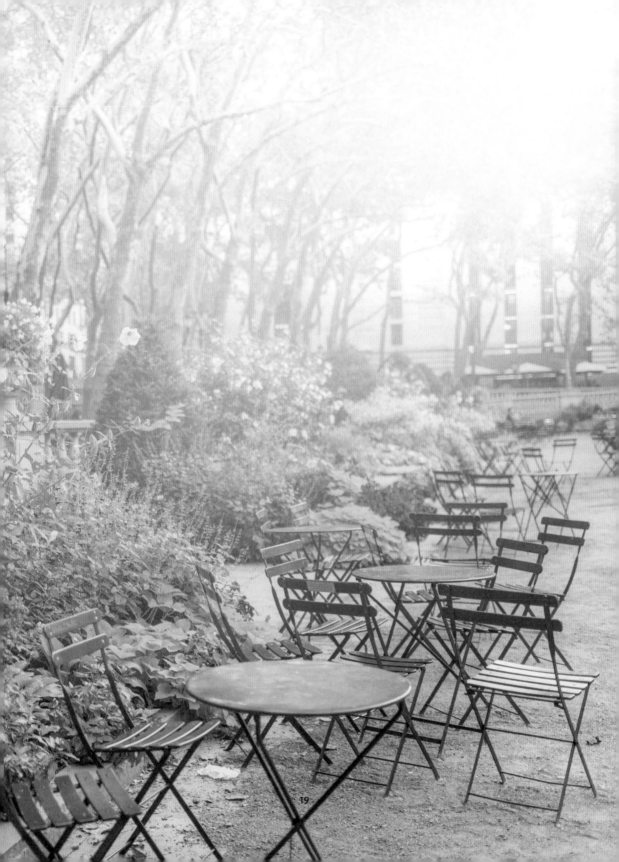

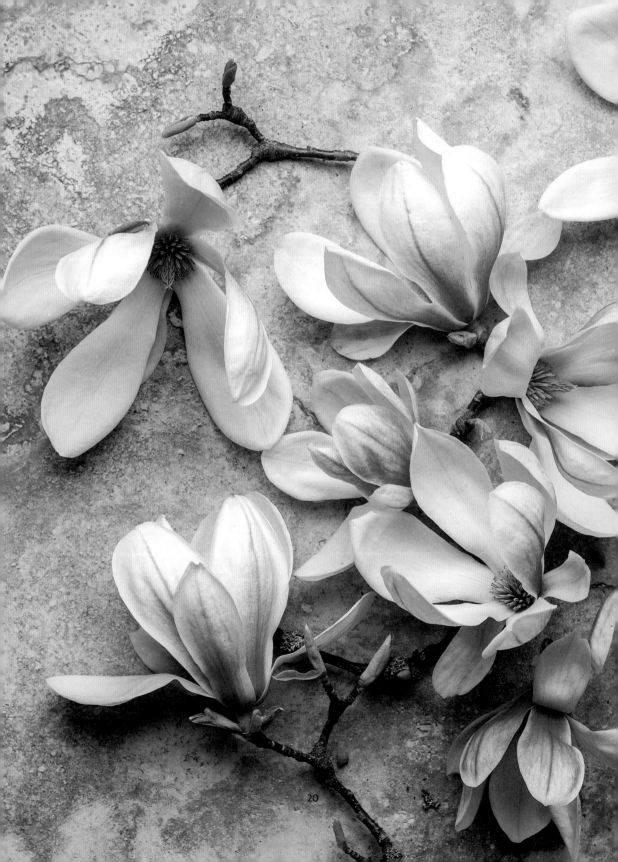

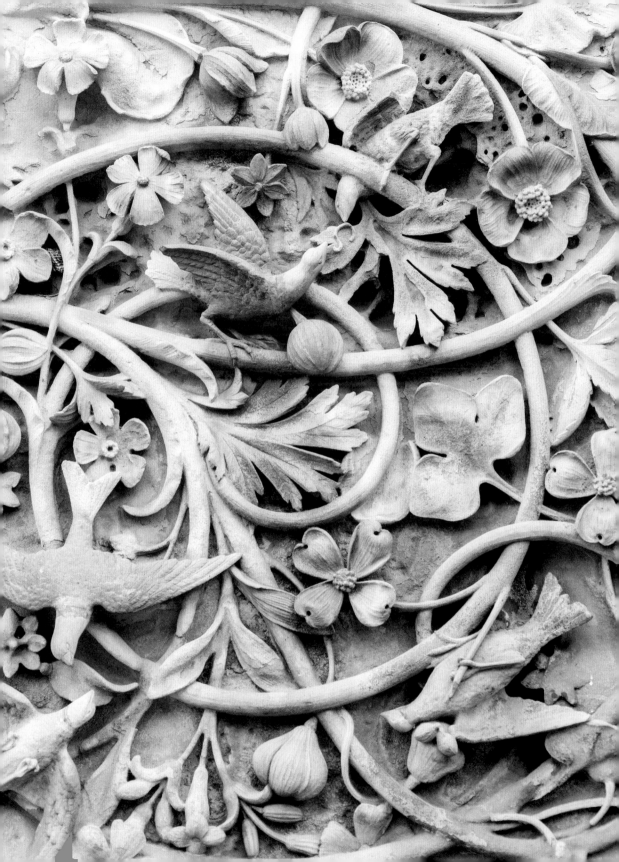

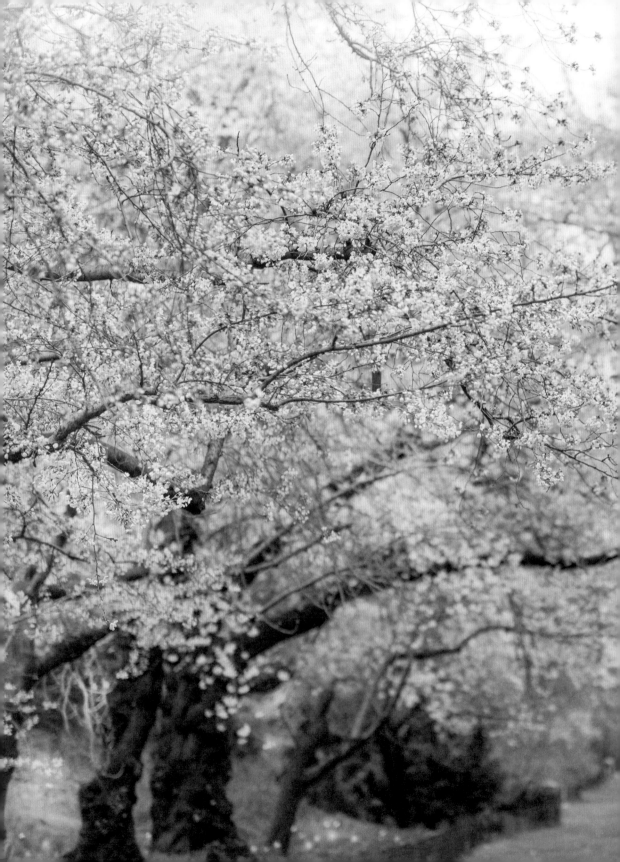

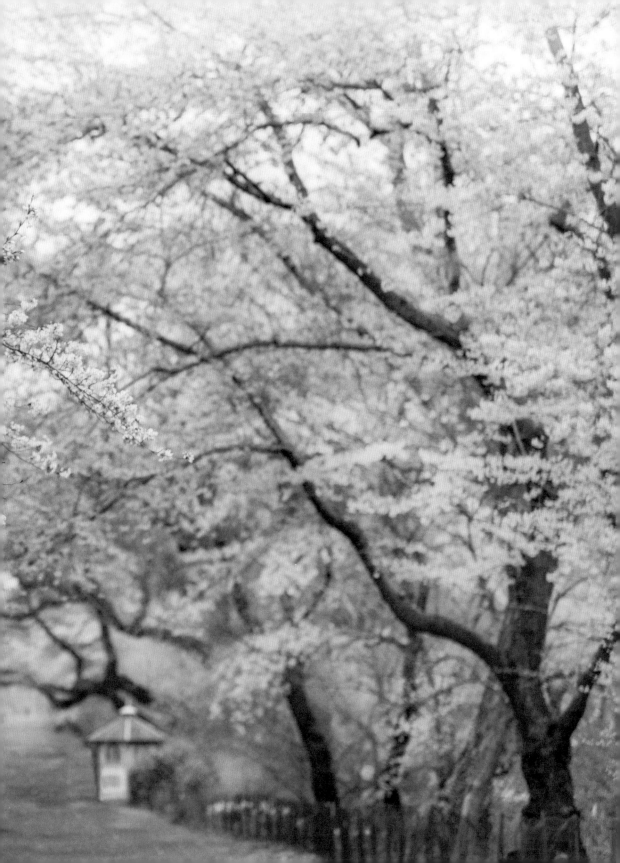

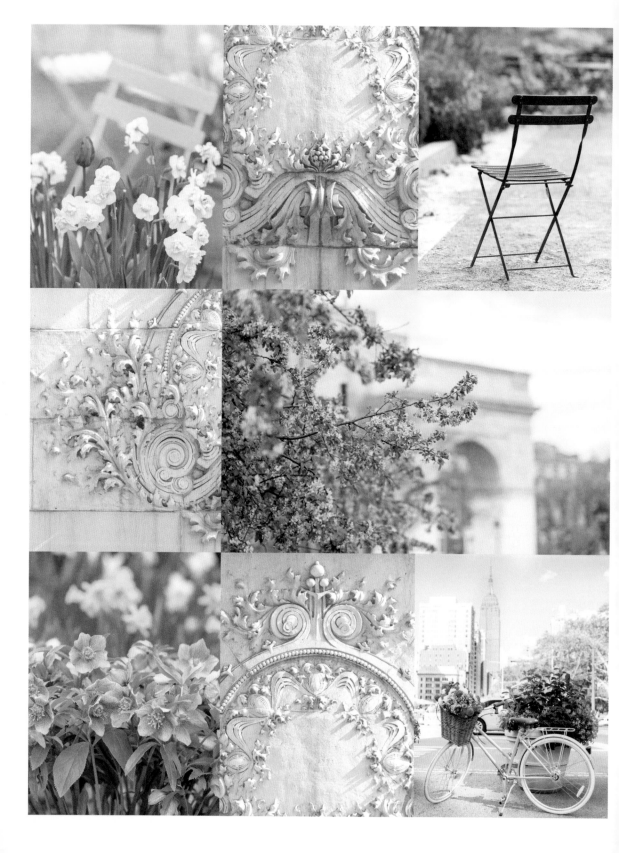

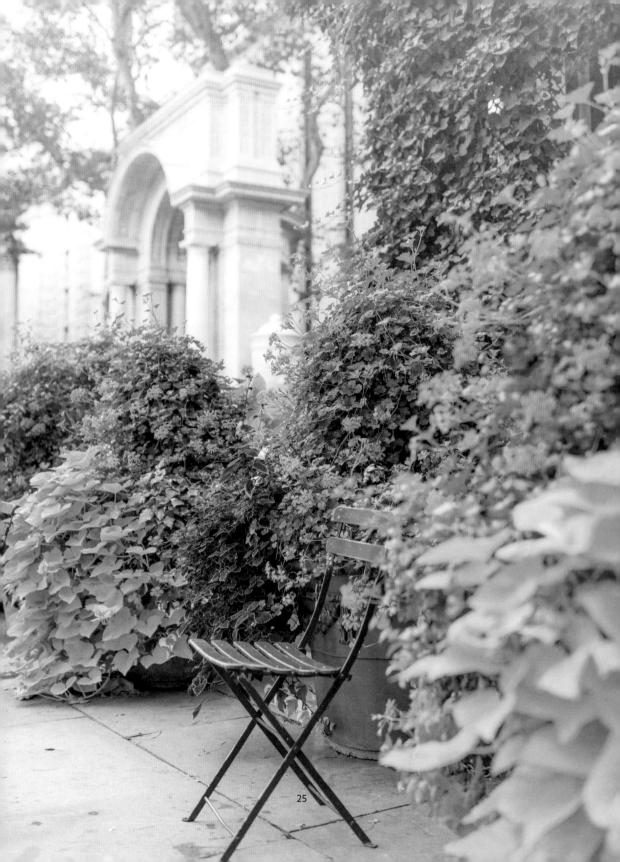

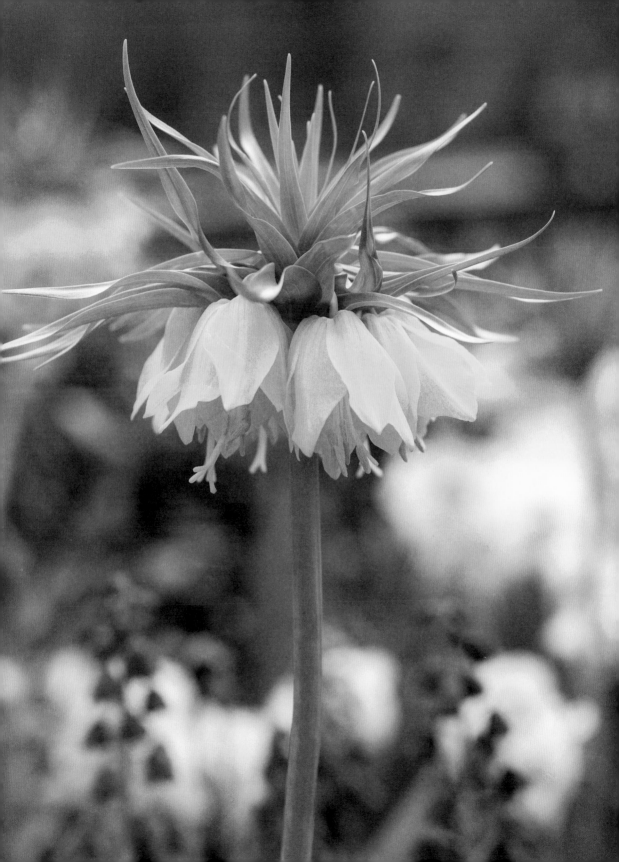

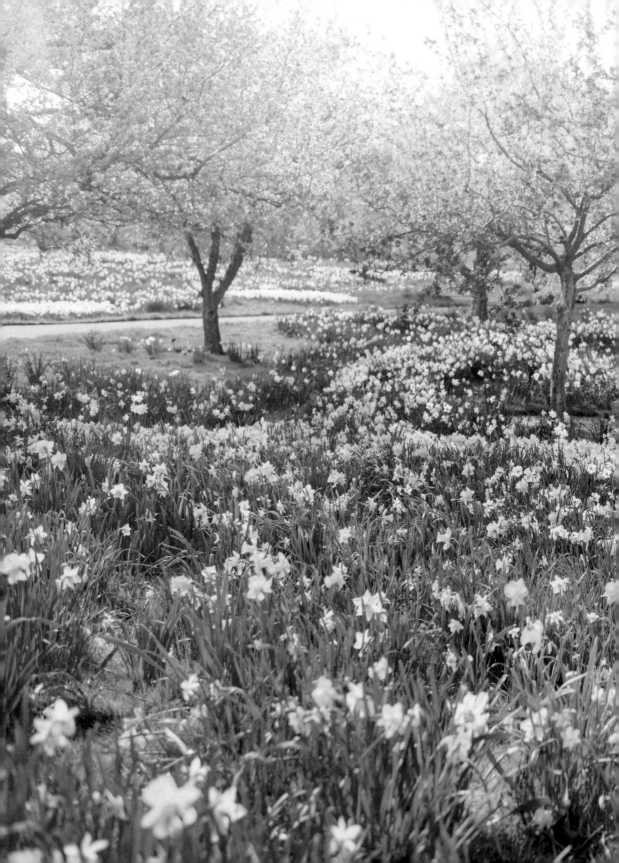

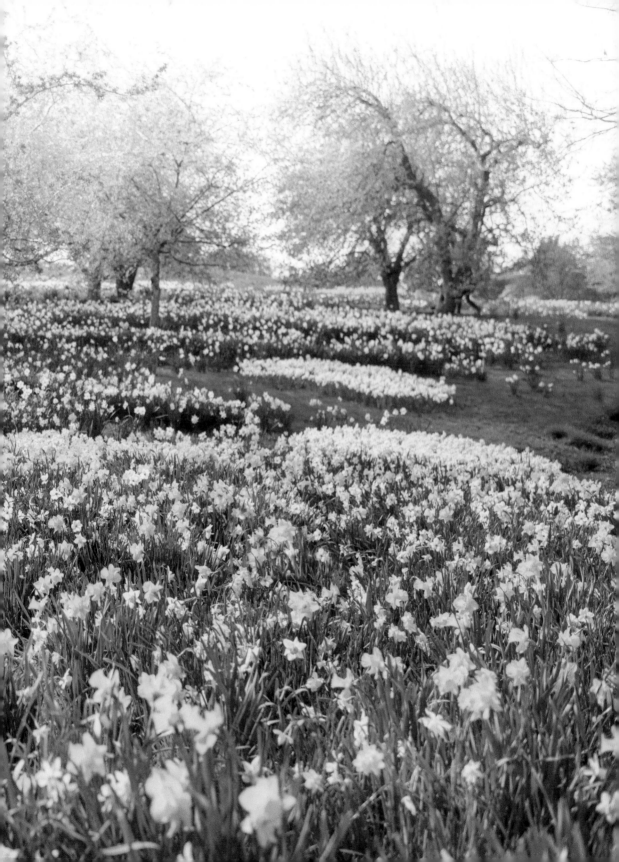

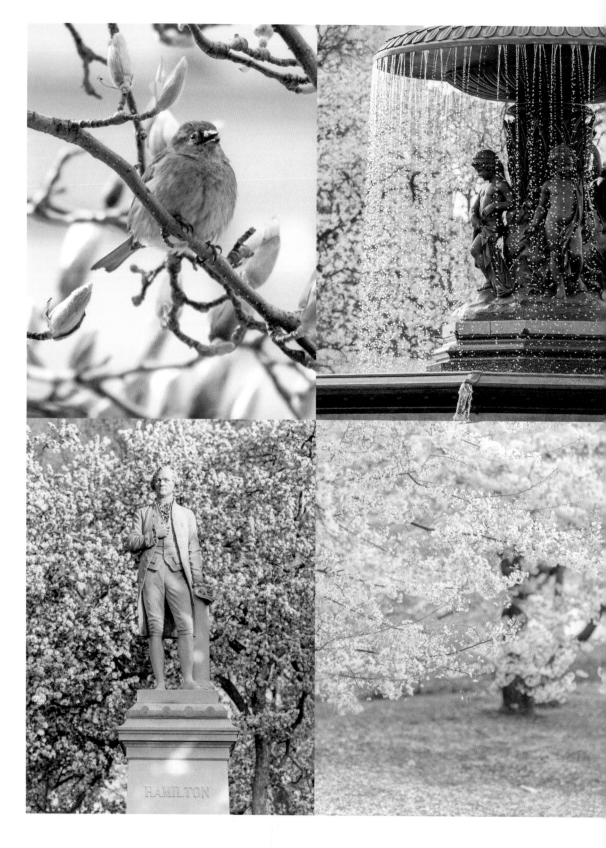

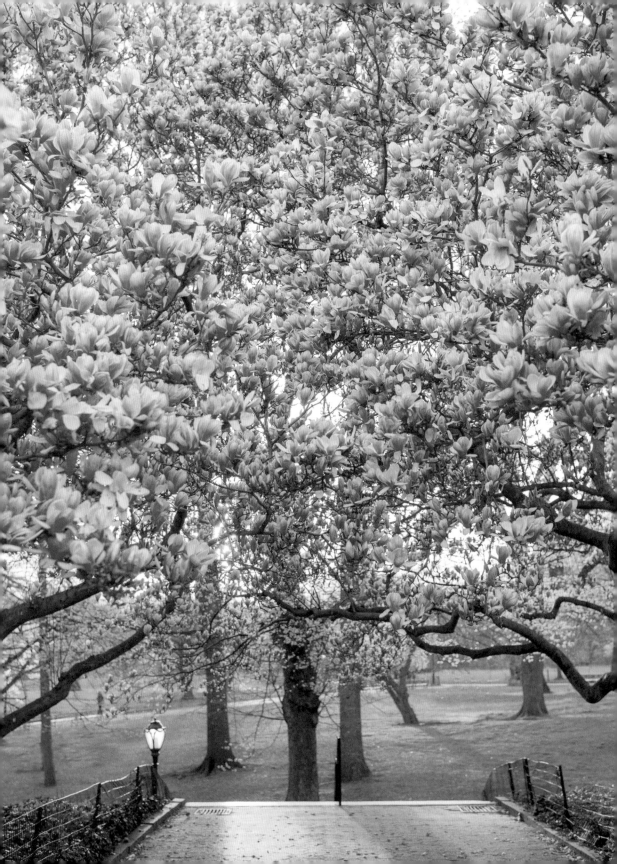

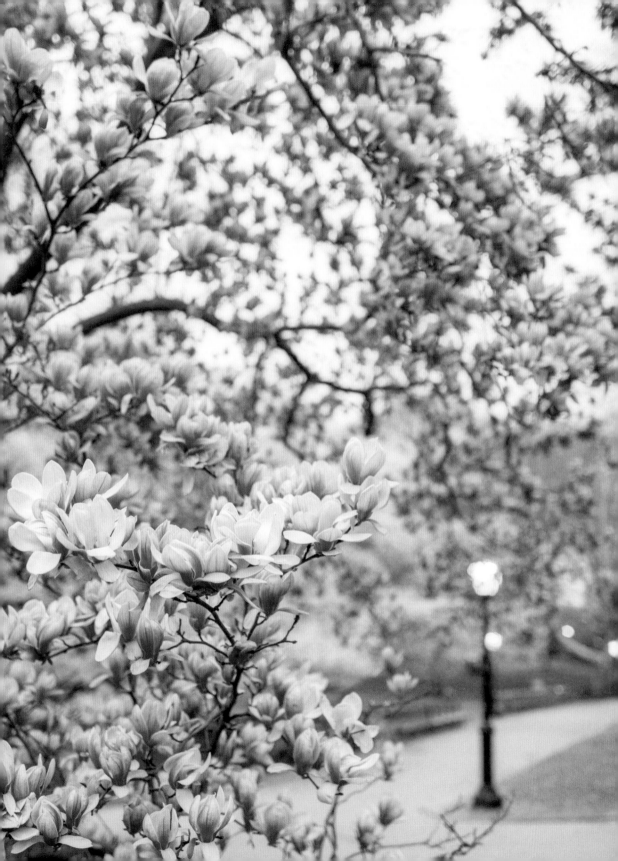

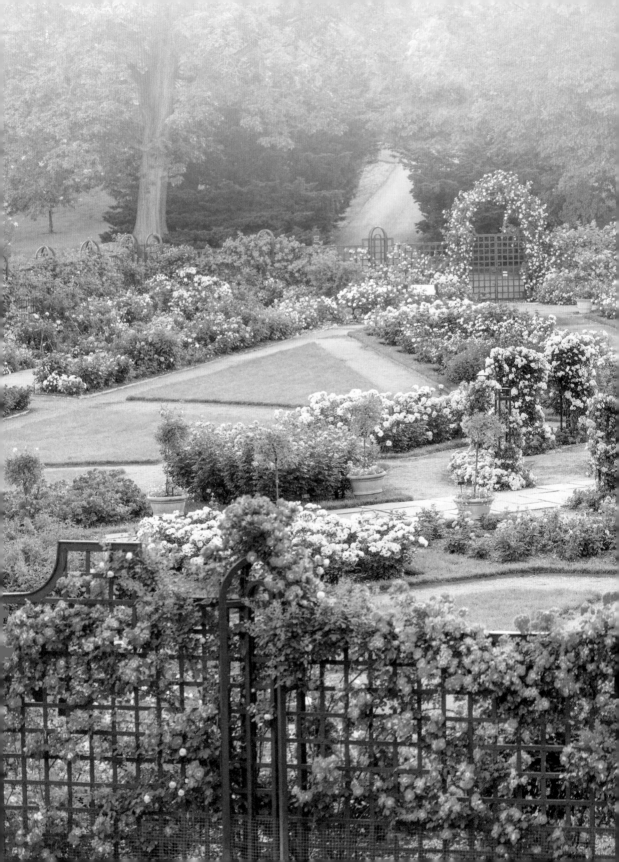

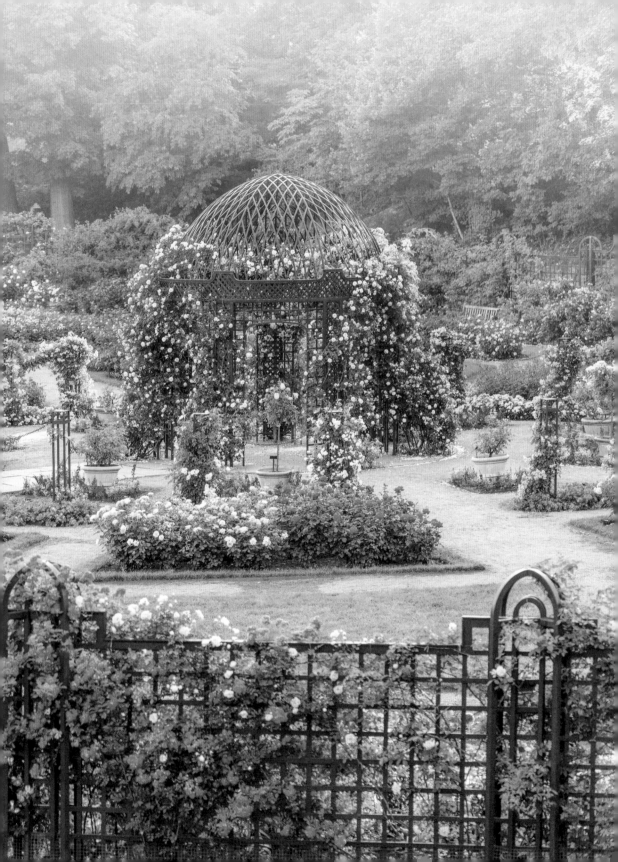

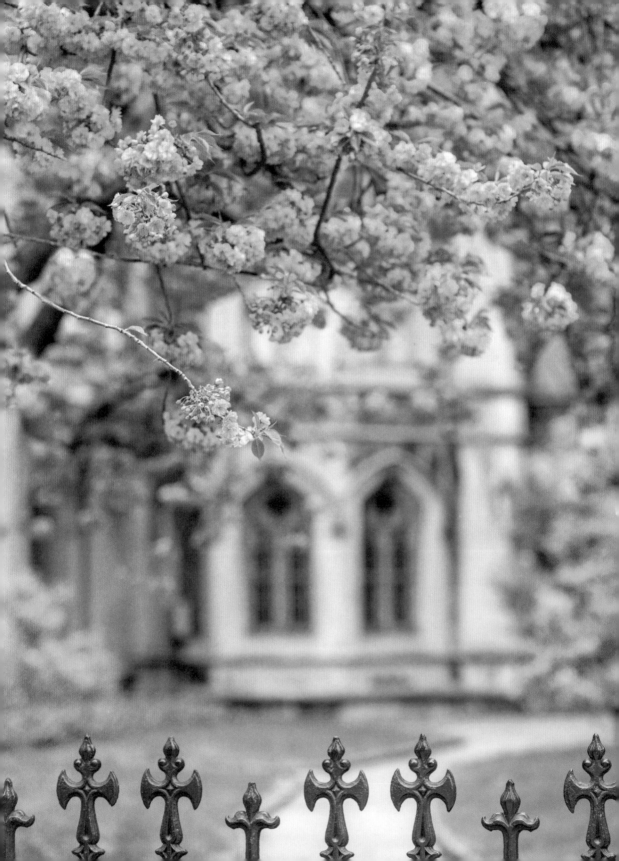

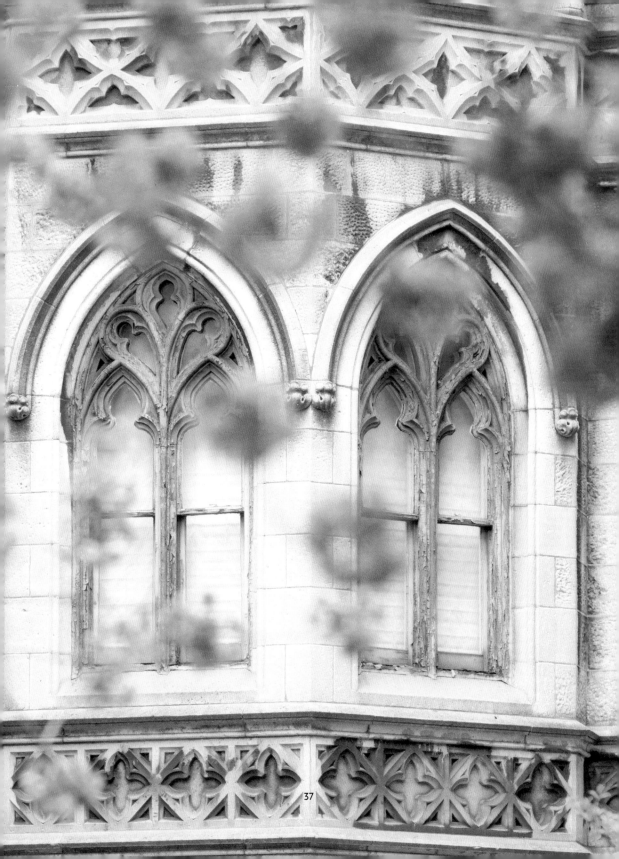

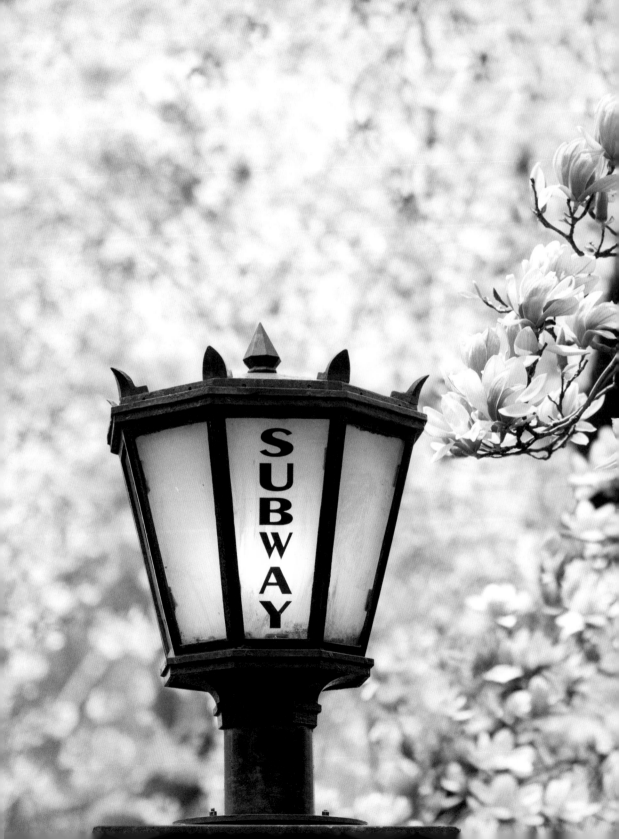

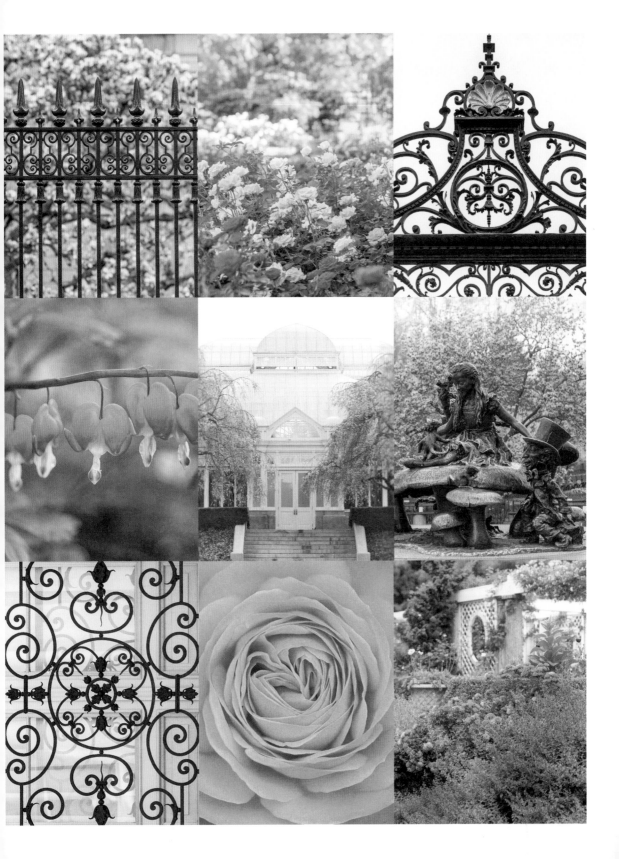

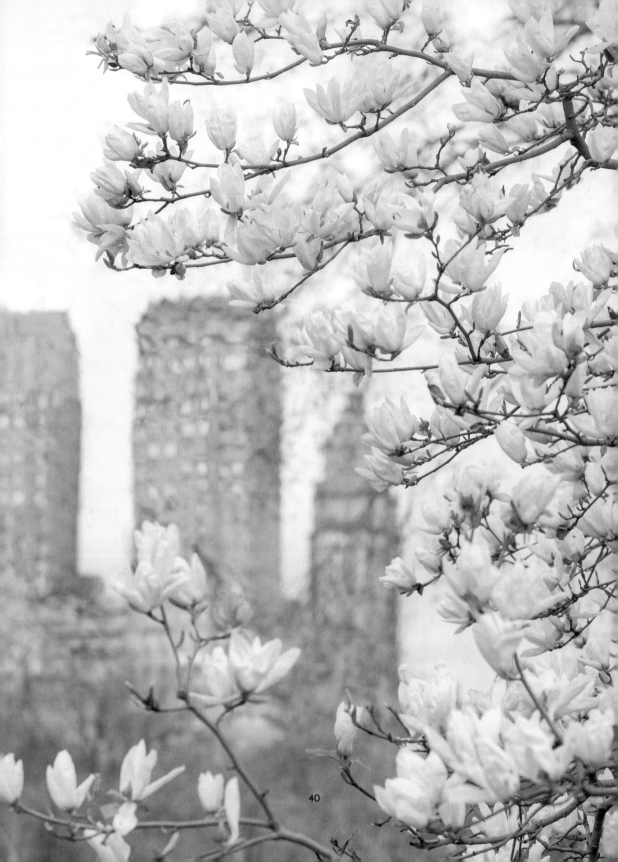

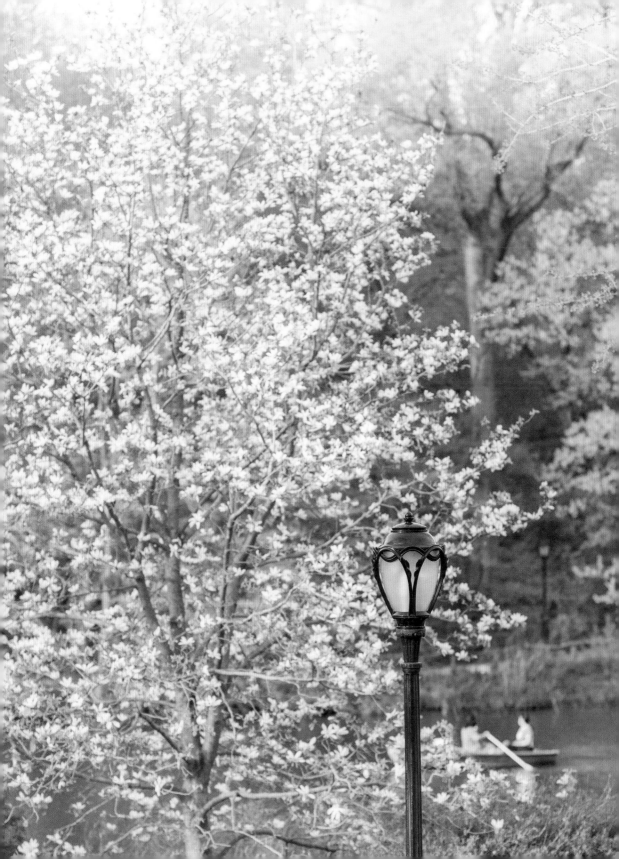

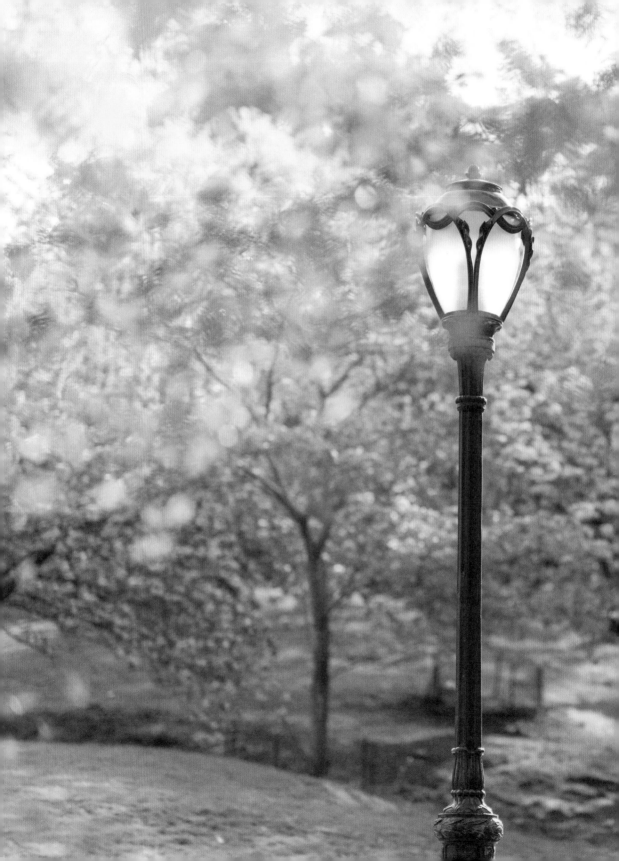

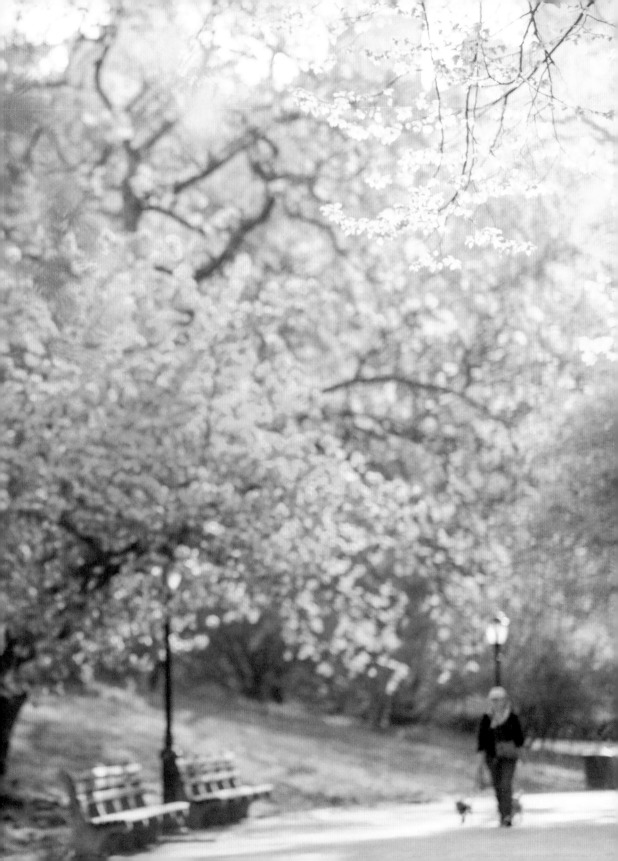

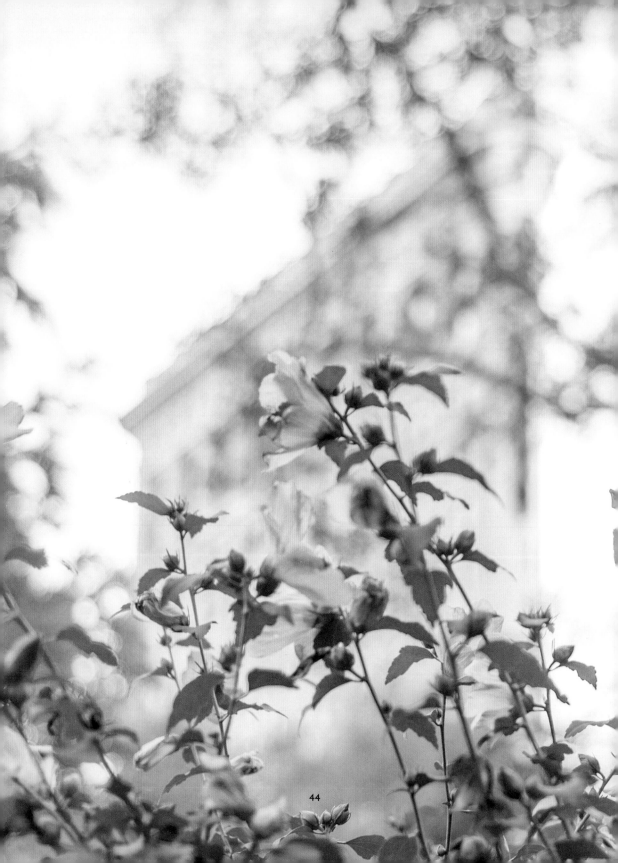

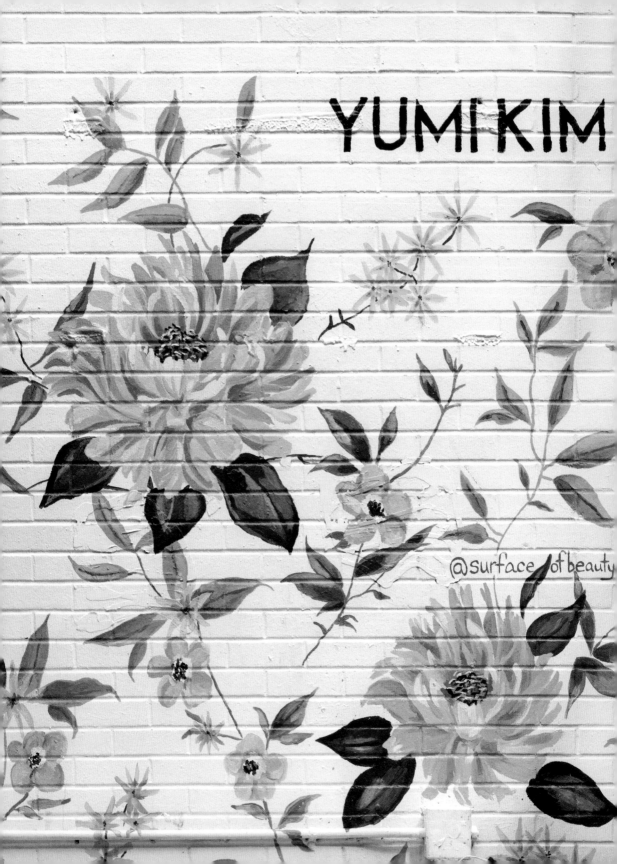

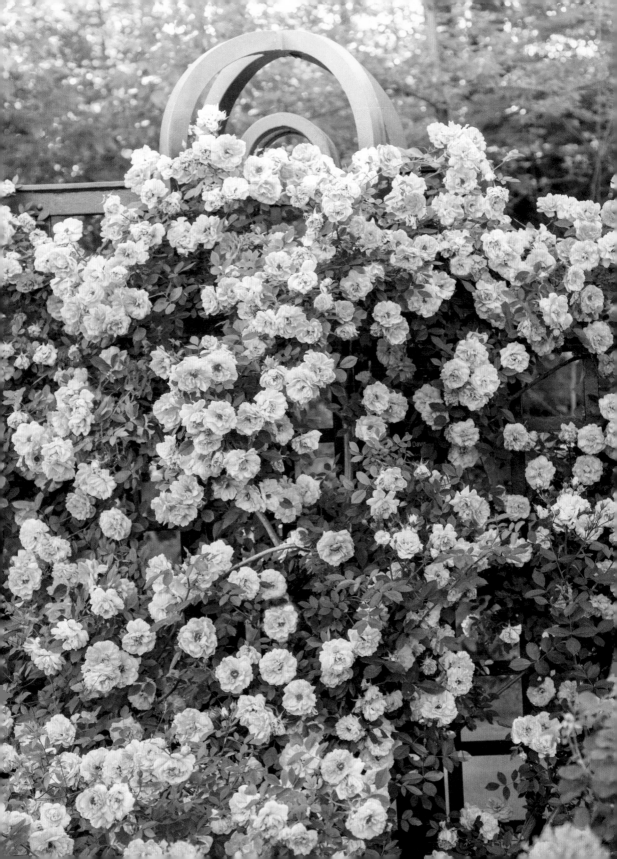

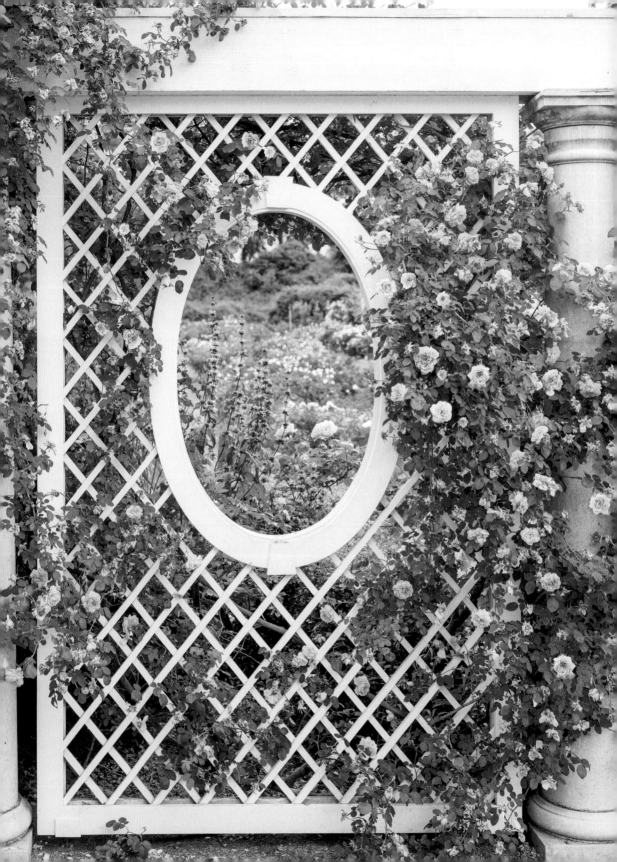

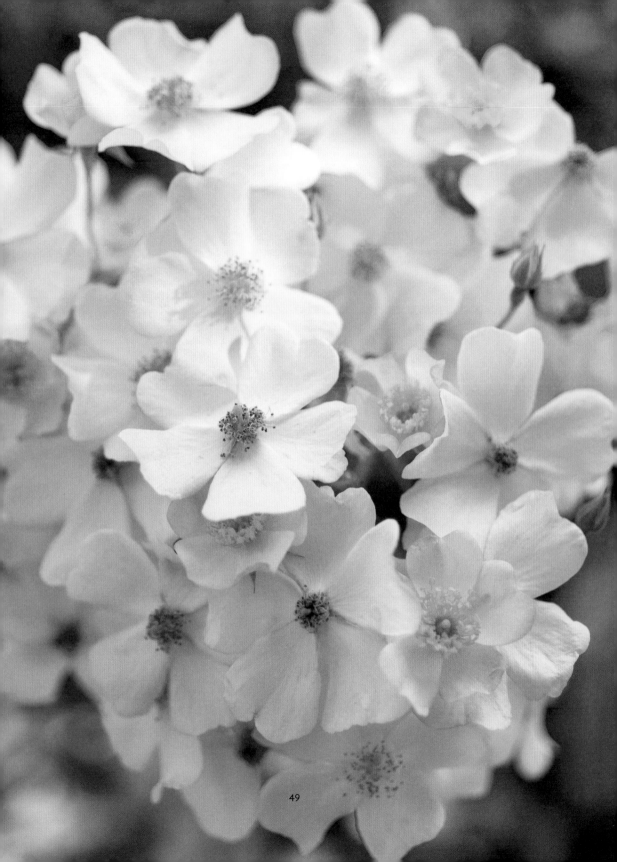

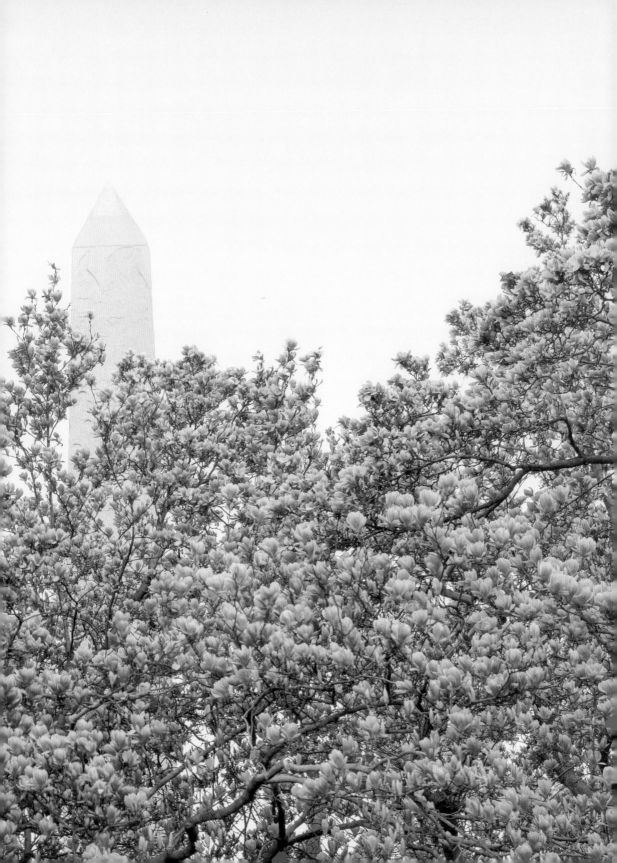

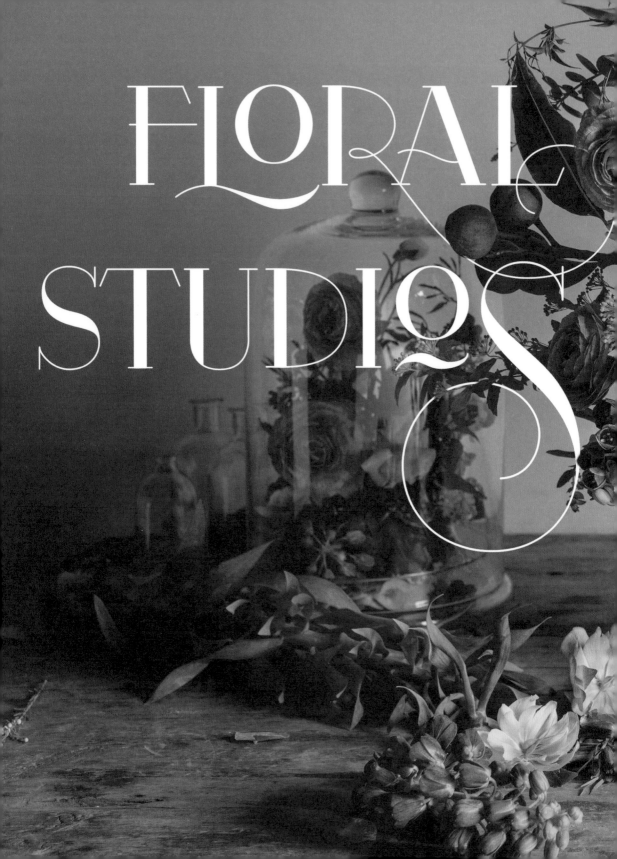

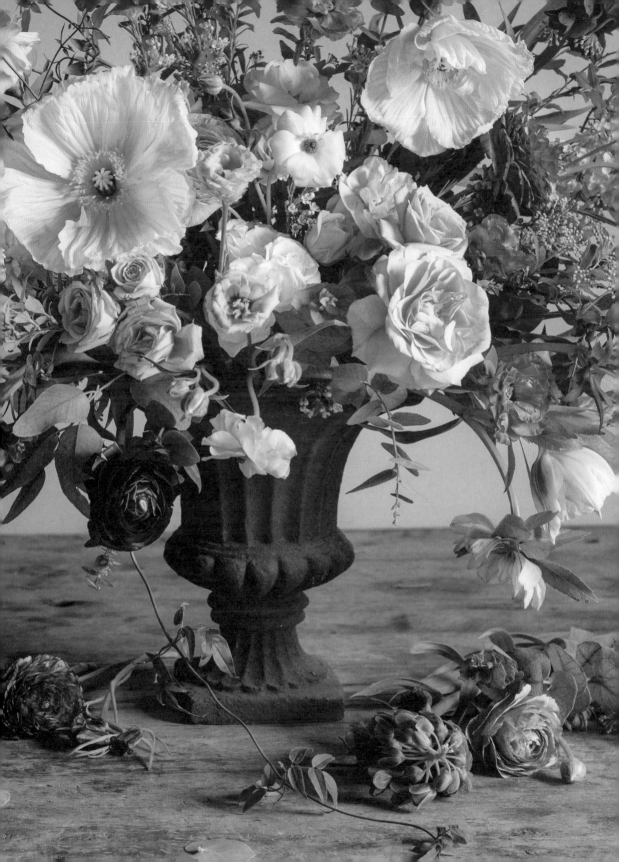

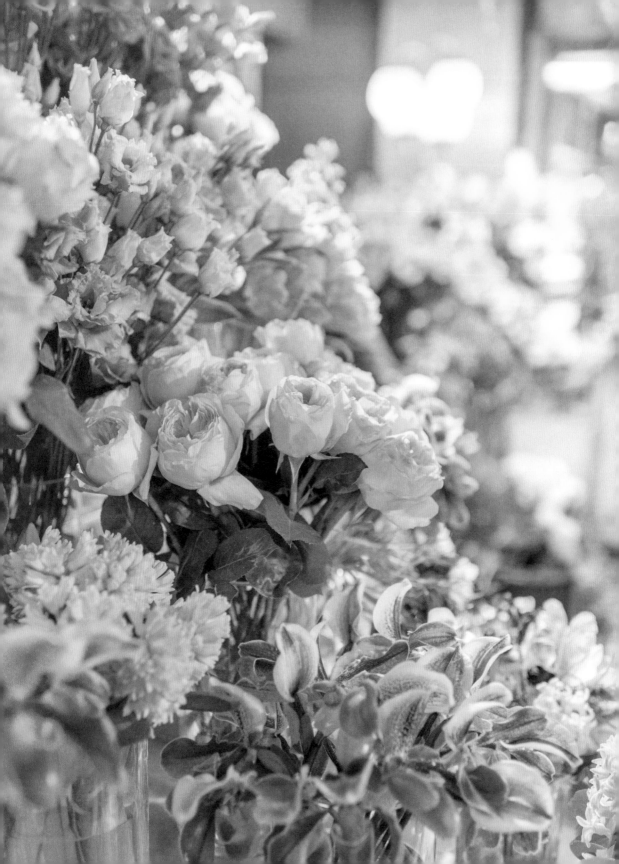

Elegant, sophisticated, grand, playful, edgy, casual, and outrageous—floral design in New York City flourishes in a panoply of styles and concepts.

Throughout the city, the floral studios creating classic arrangements as well as cutting-edge designs are not limited to the traditional corner shops with their always-tempting window displays. Rather, these studios are as likely to be found in a converted brick warehouse in Brooklyn or a dedicated section of a stylish home decor store in SoHo. They may even be located in an appointment-only atelier on West Twenty-Eighth Street, directly above the wholesale flower market, for ready access to the city's primary source of freshly imported materials.

Their creations range from breathtaking rose-and-hydrangea arches for weddings to jaw-dropping fashion show installations. A recent extravaganza created by Putnam & Putnam for designer Jason Wu featured soaring columns wrapped in thousands of purple, magenta, and yellow anemones and sweet peas.

A growing trend in events and in fashion magazine photography has been a return to lavish arrangements and installations reminiscent of still lifes by the Dutch old masters or the nineteenth-century French painter Henri Fantin-Latour, celebrating the sensual beauty of dramatic floral shapes and colors. Rich, opulent blooms in regal shades of plum, gold, and copper include poppies, ranunculus, fritillarias, garden roses, tulips, narcissus, and hellebores. Romantic creations feature luscious dahlias, lilies, and irises in stone urns, mixed with spilling foraged branches and accented with arching foliage, trailing

vines, and bending stems. Feathery tendrils of clematis or jasmine add visual movement, catching the light and bringing a touch of enchantment and mystery. Glass cloches are filled with ranunculus, delicate snowdrops, and grape hyacinths, draped with moss, creating a miniature spring woodland. Daffodils, the official flower of New York City, in shades of pale yellow, white, and pink, mingle with lilac, tulips, and lily of the valley.

Other designers take a more minimalist approach, utilizing multiple clear glass cylinders of varying heights or square bowls filled with sculptural calla lilies and orchids.

In temporary pop-up shops within larger retail outlets, loose, romantic hand-tied bouquets, inspired by botanical prints, are lovingly gathered and wrapped in white or kraft paper as a responsible alternative to plastic. The emphasis is on providing sustainable, regionally grown flowers that support local farms.

But many New York City florists *do* present the classic vision of a charming local flower shop. University Floral Design, a venerable Greenwich Village institution, family-owned since 1928, is a delightful jewel box of a boutique, dressed in a vintage green sign with gold script. Inside, exquisite displays of flowers in season are stacked from floor to ceiling. Blush-colored spray roses in a huge container nestle alongside lisianthus, snapdragons, and oriental lilies in clear bowls. Long-stemmed roses in symmetrical glass vases grace a wall. In fair weather, the cut flowers and potted bright pink hydrangeas spill out onto the sidewalk, causing pedestrians to stop in admiration.

If you dream of creating such splendid arrangements for your own home, many New York City studios offer weekend or seasonal classes and workshops in specific techniques for use in bouquets, centerpieces, or arches. Although often a considerable investment, the classes include all materials, and you'll be able to spend the day with a floral hero, learning tricks of the trade in a friendly, relaxed environment. Luncheon, a professional photographer, and endless buckets of irresistible fresh blooms are often provided to contribute to a memorable and one-of-a-kind learning experience.

Life is abundant with personal and public celebrations that can be elevated to the sublime by adding the ephemeral beauty of a stunning floral composition. What may seem an indulgence might just become the crowning feature of an already momentous event. In New York City, thanks to the passionate artists in hundreds of floral studios, that happens every day.

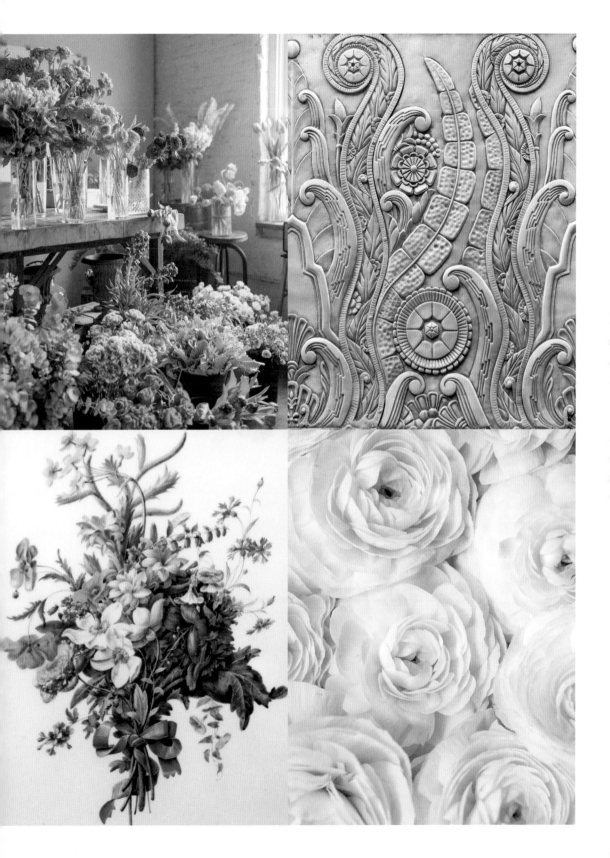

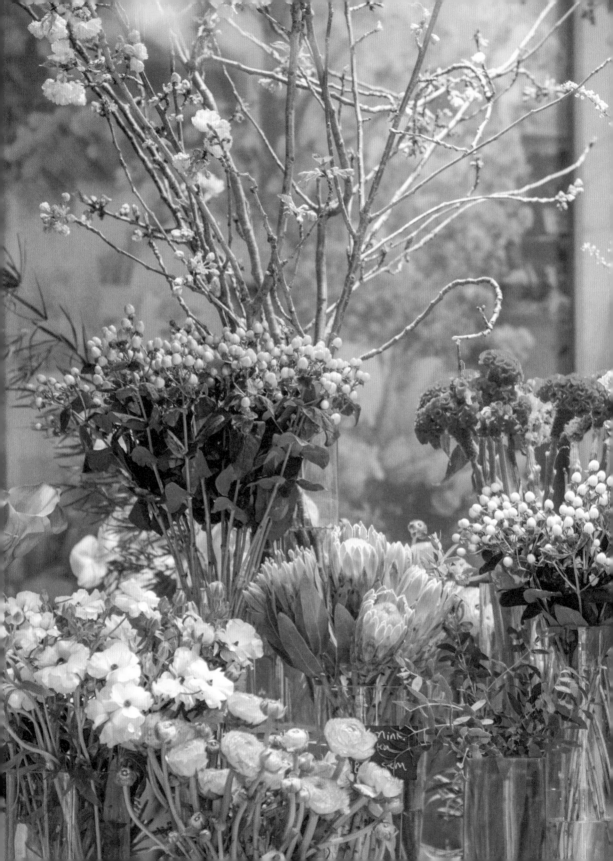

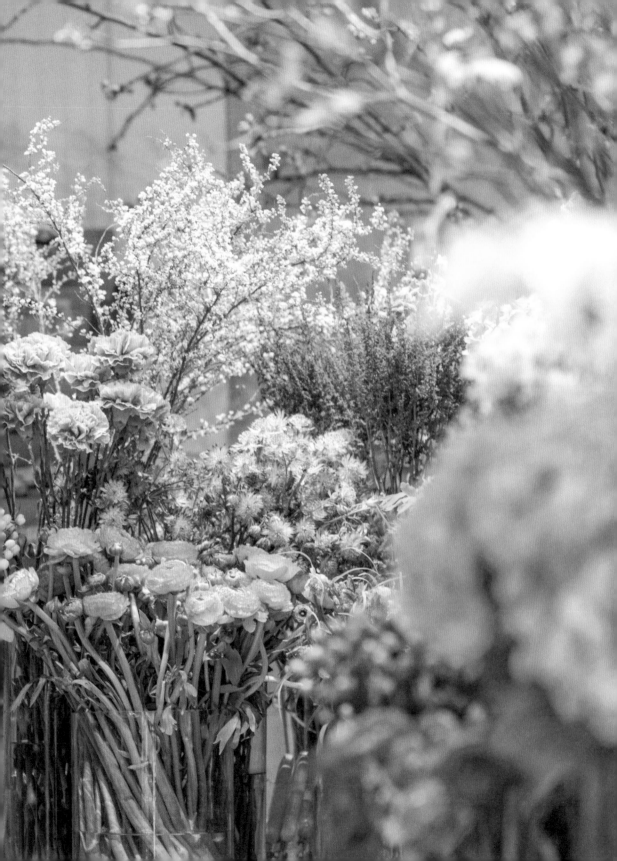

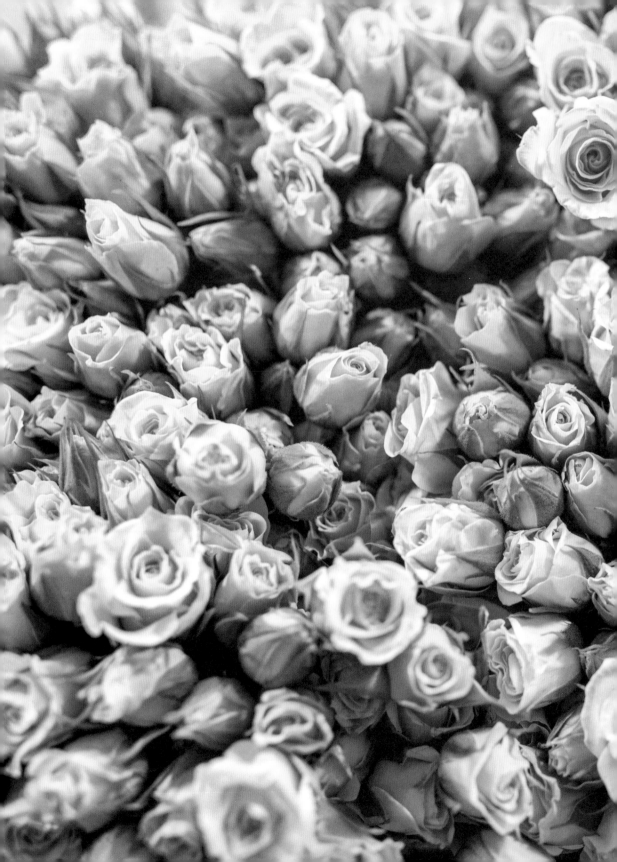

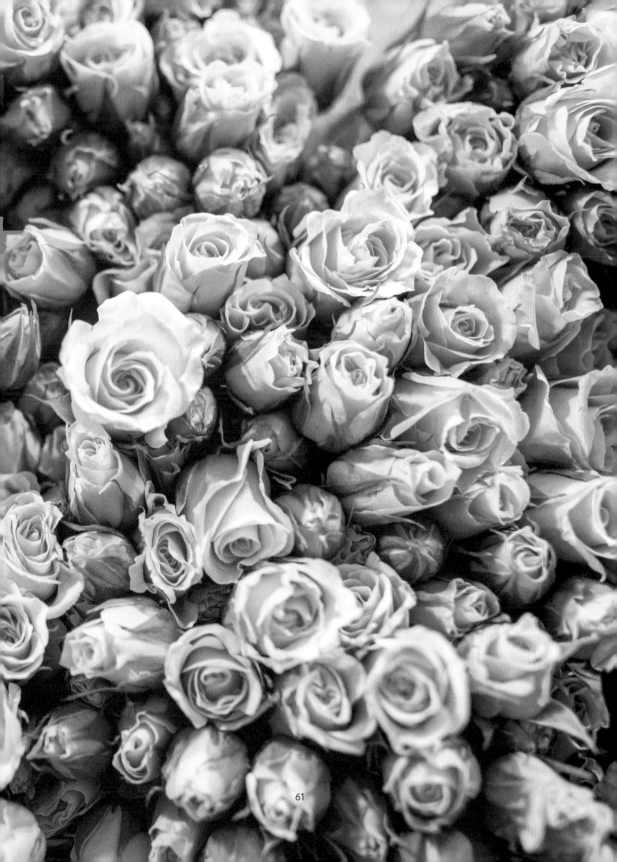

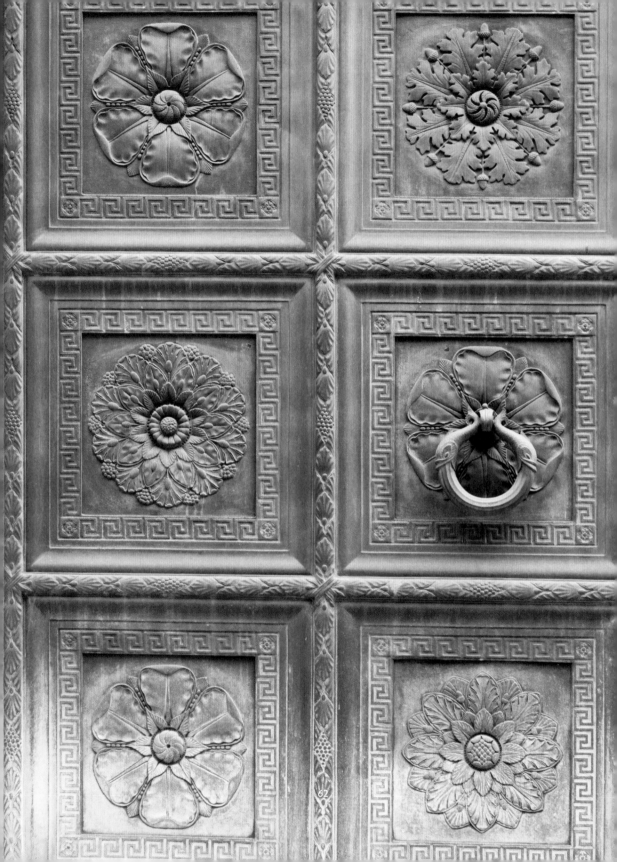

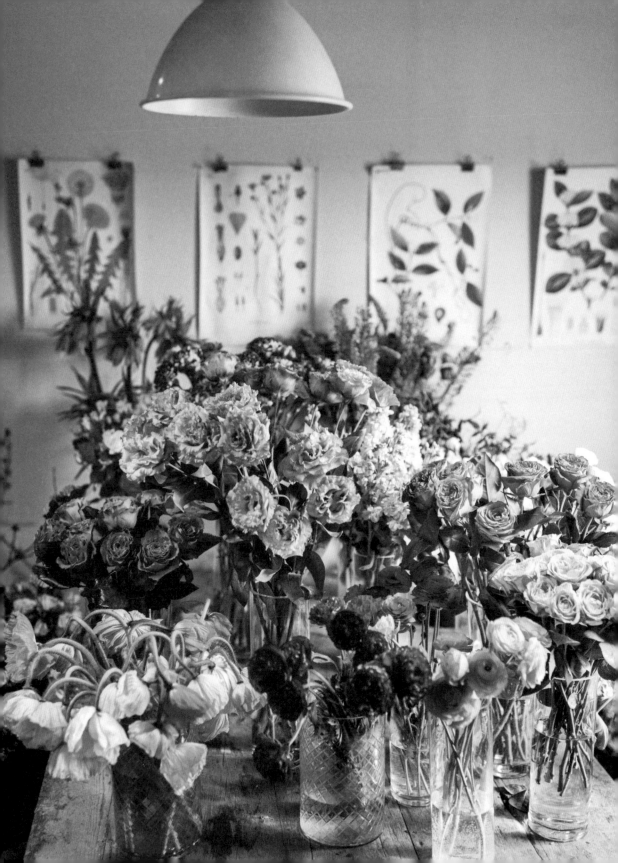

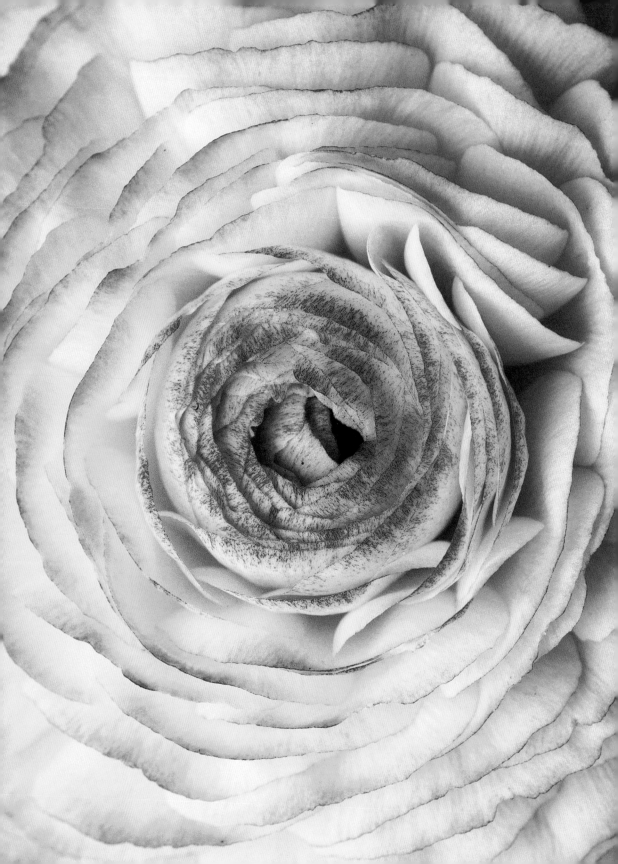

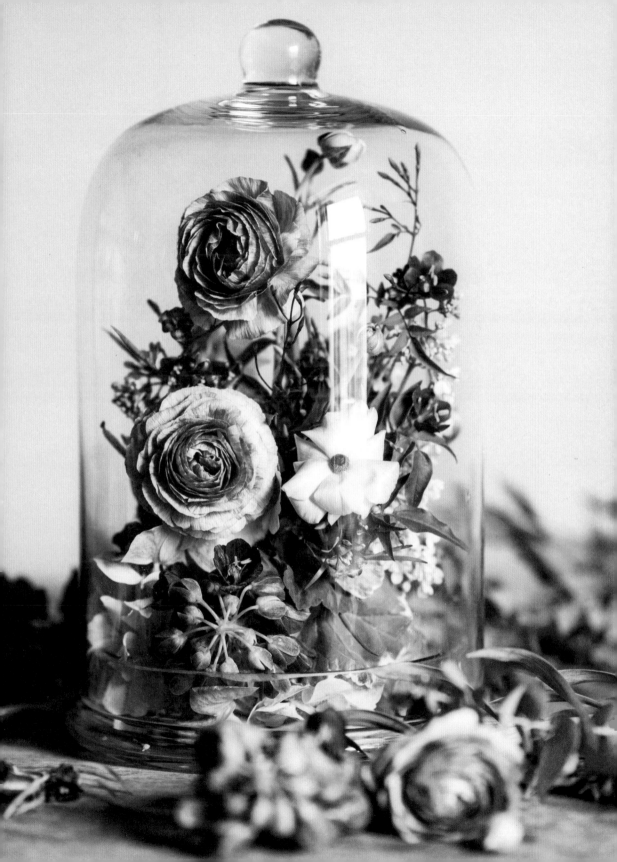

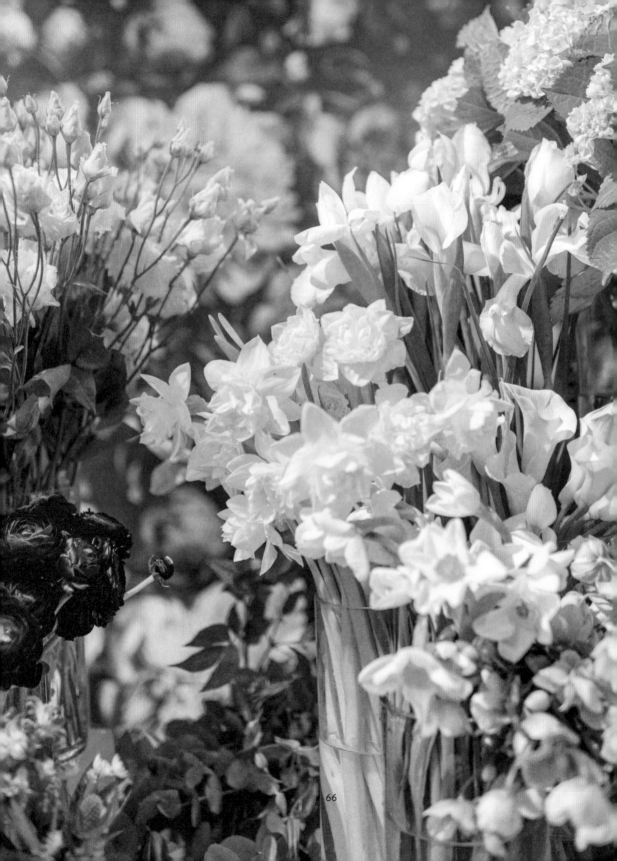

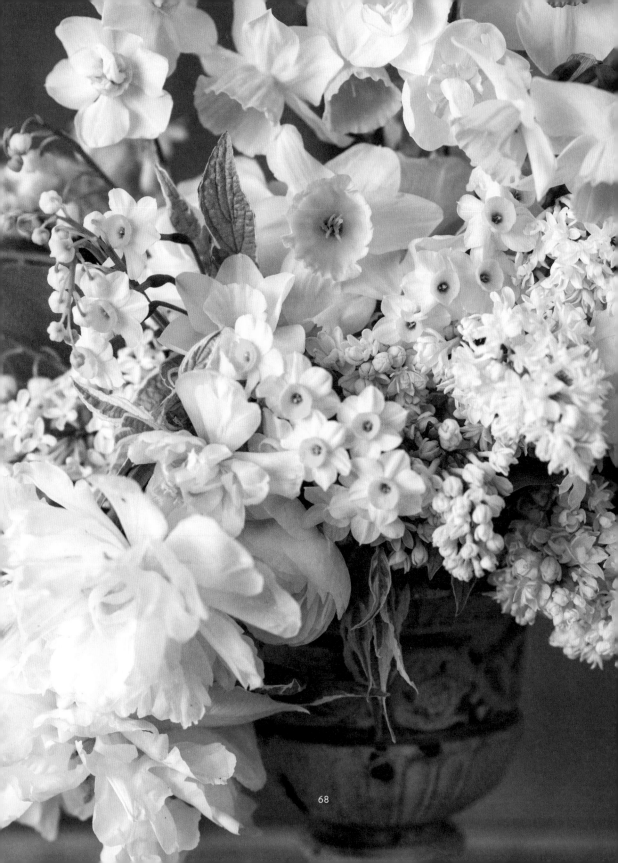

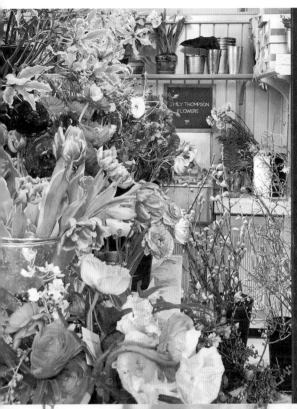

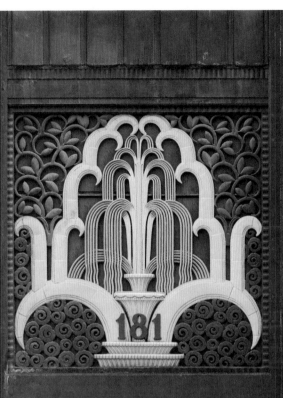

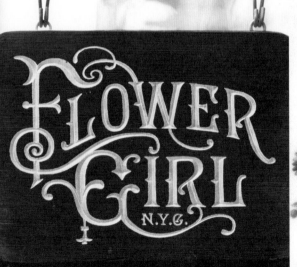

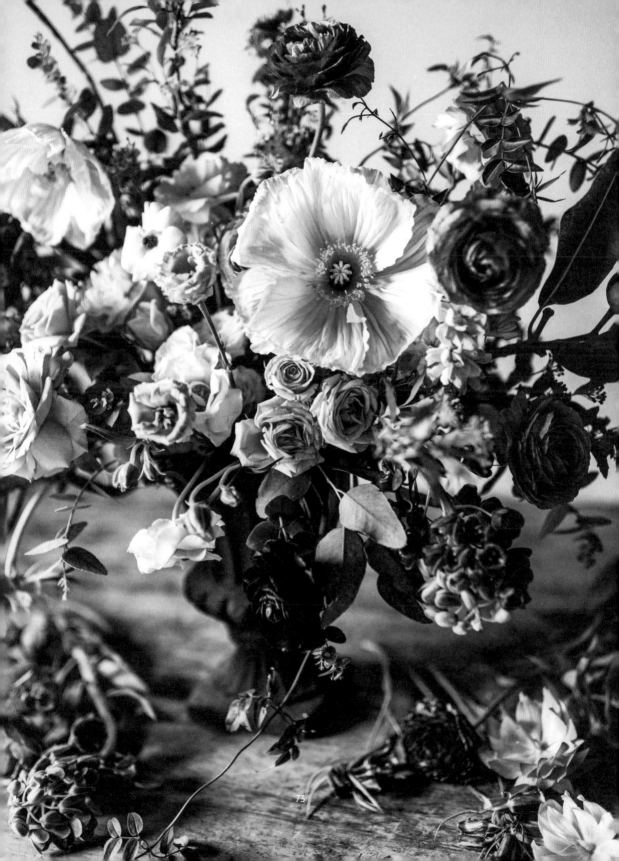

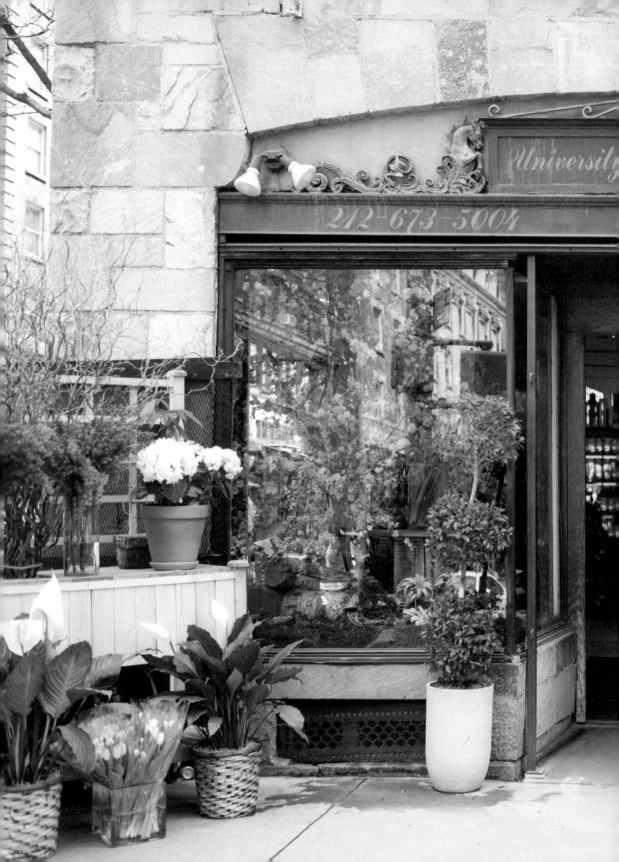

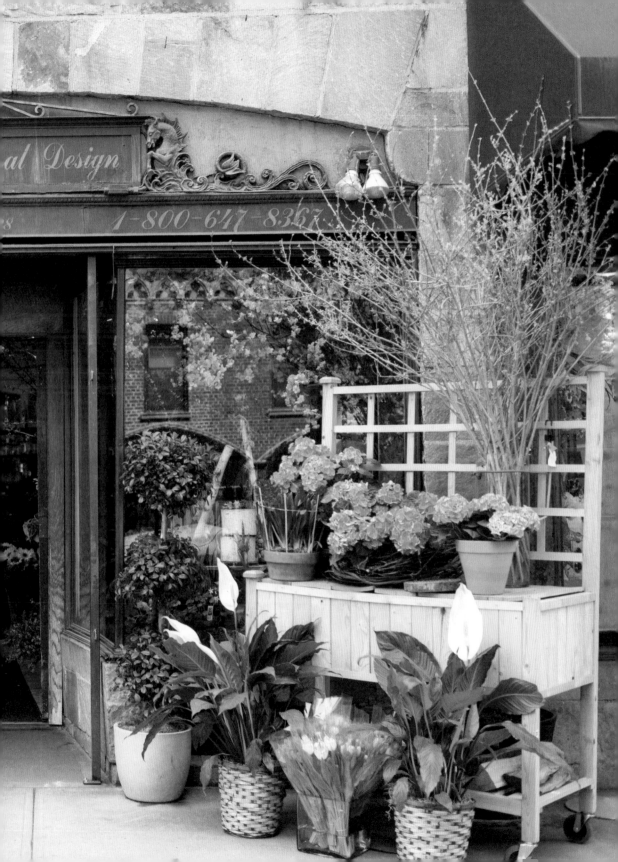

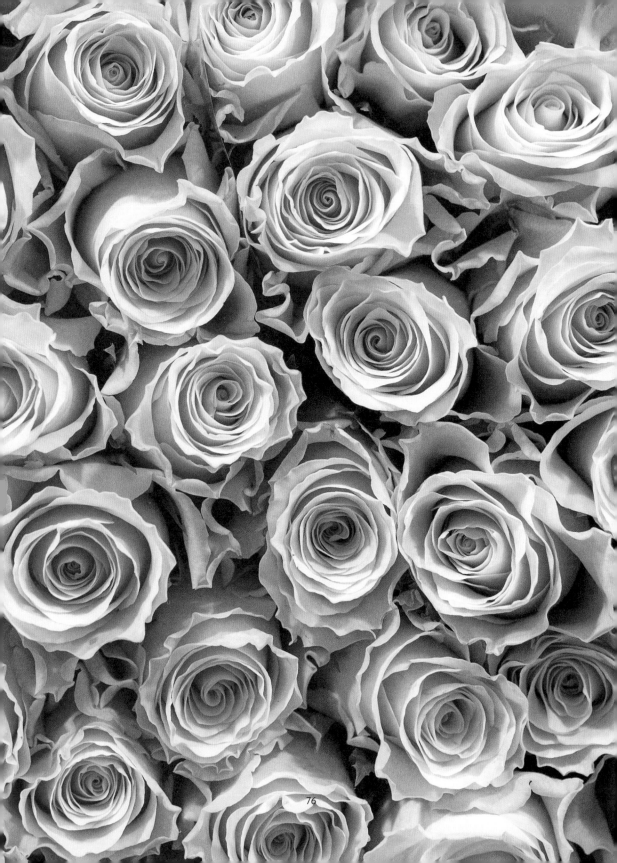

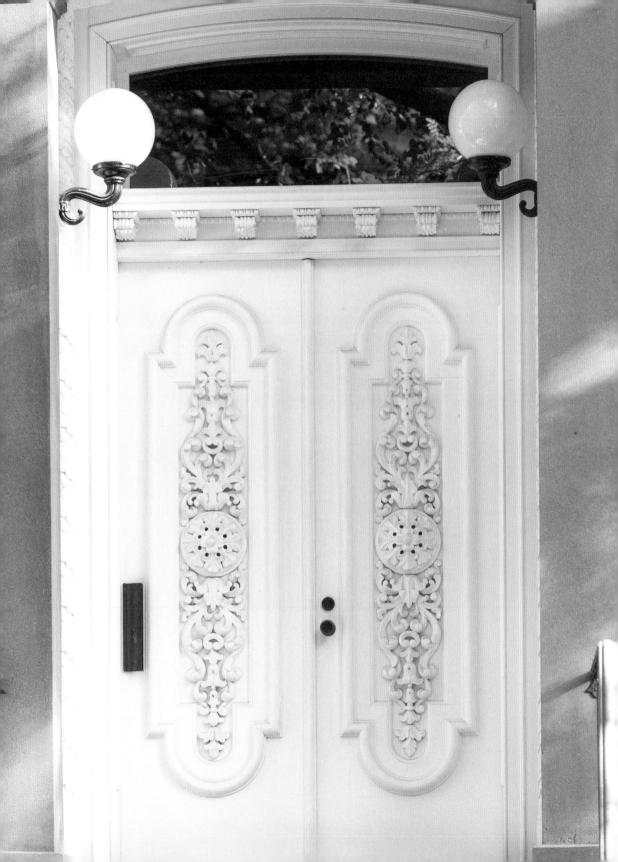

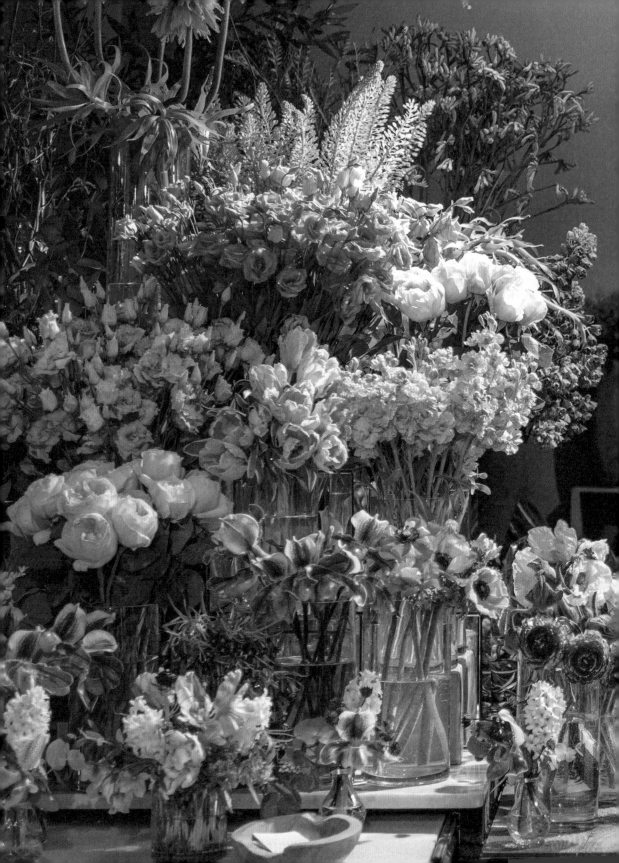

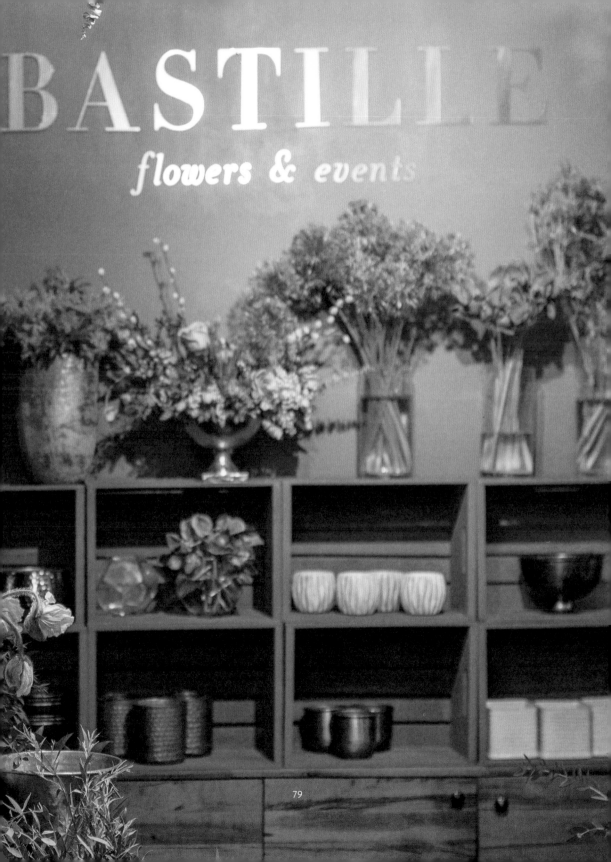

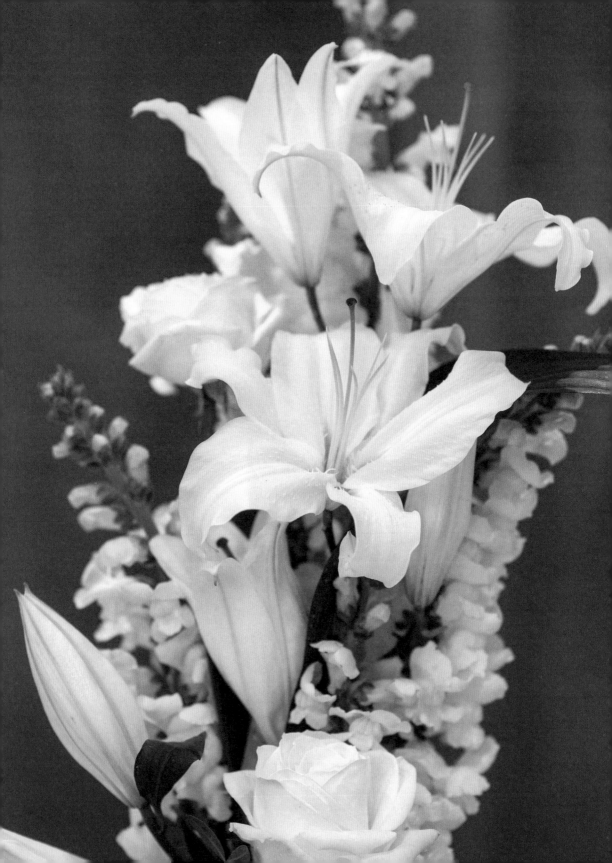

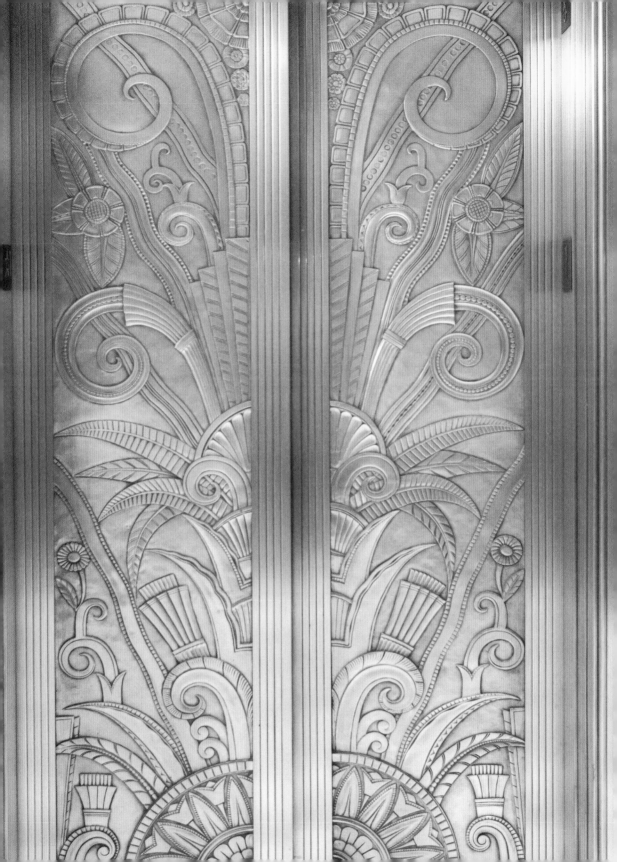

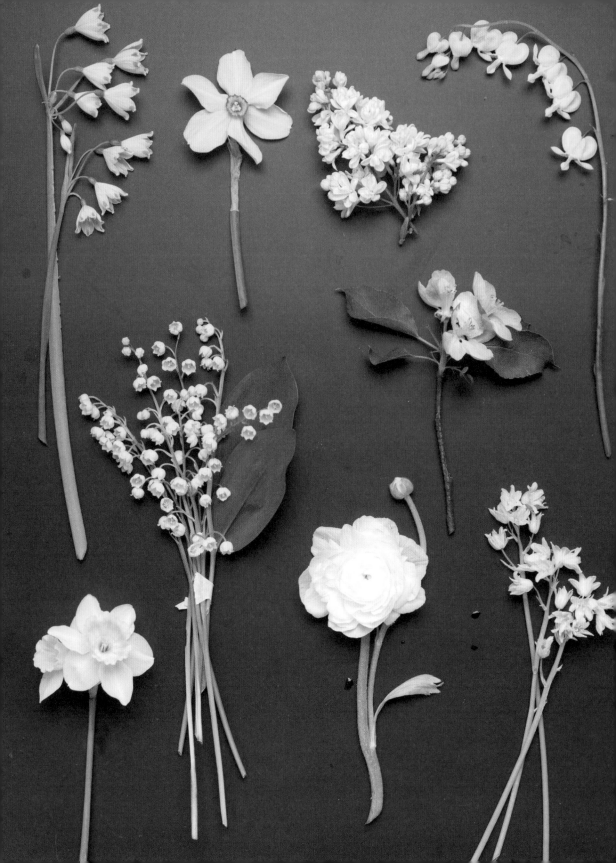

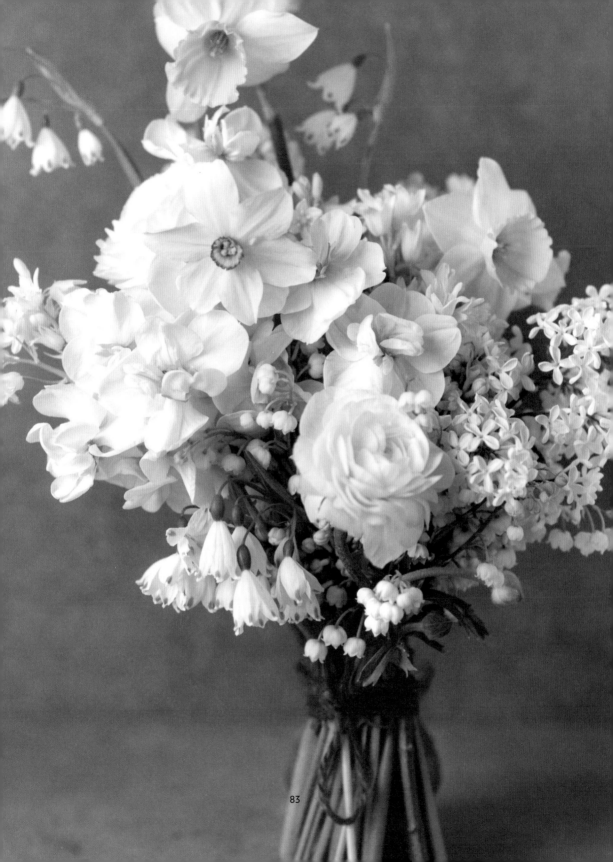

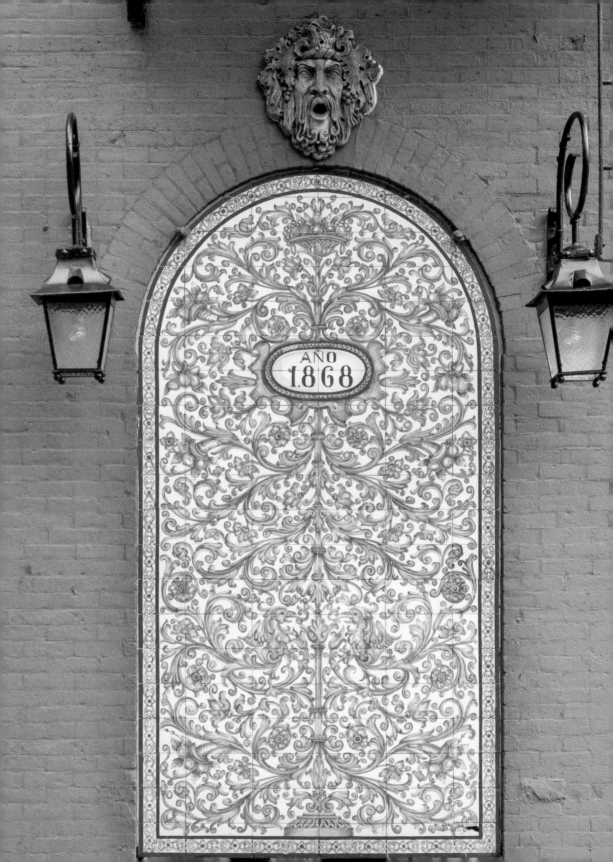

MARKET FLOWERS

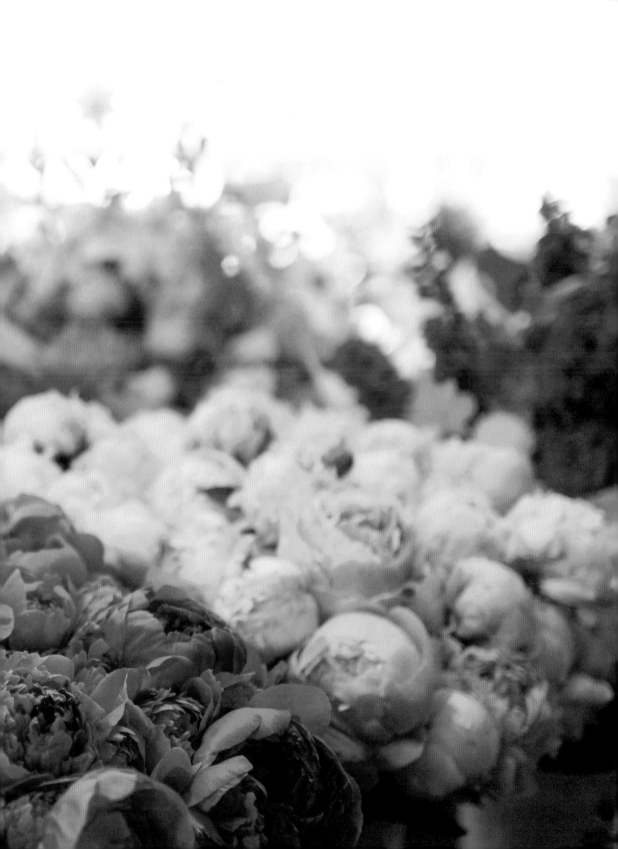

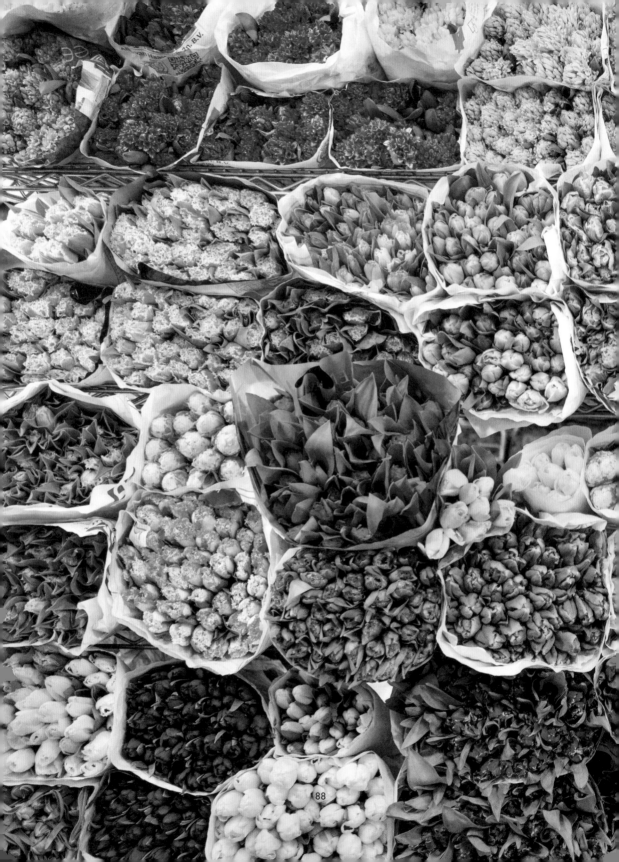

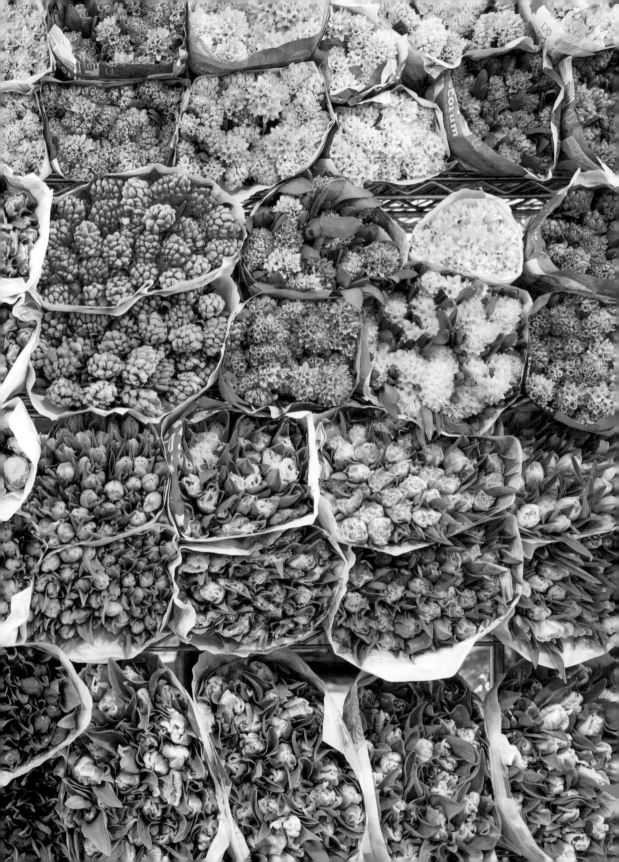

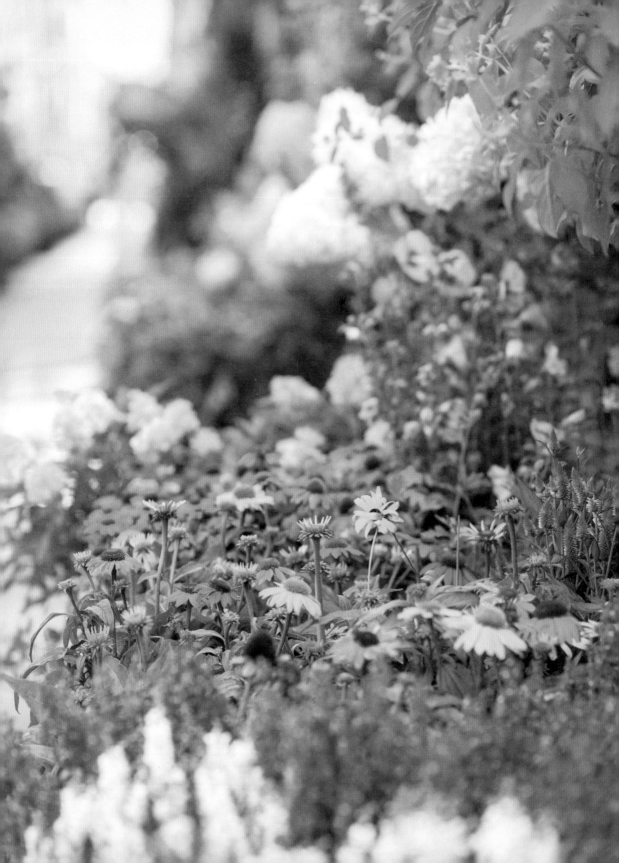

Whether an extravagant, paper-wrapped bundle of perfect roses or a humble potted African violet, flowers allow us to observe and experience the rhythms of nature on an intimate scale—beauty budding, blooming, and decaying, the cycle of botanical life in miniature. Even a tiny flowering plant requiring care and nurturing provides a deliberate and mindful break from the staccato pace of a hectic day in the great city. And graceful, scented, colorful blossoms inspire dreams of spring amid the long, dull expanse of an urban winter.

From Brooklyn to the Bronx, from the West Side to the East Side of Manhattan, New York City is rich in sources of fresh-cut blooms year-round: Street corner stands, neighborhood shops, farmers' markets, and grocery stores provide the materials to make your own arrangements, as demonstrated in the first appendix.

Outdoor greenmarkets are favorites for seasonal flowers and small potted annuals, and make a wonderful weekend excursion. The Union Square Greenmarket is a destination for regional floral varieties, which shoppers pair with purchases of organic fruits and vegetables. In spring, racks of potted pansies, daffodils, and tulips, along with buckets of pussy willow and peach blossom branches, cluster under blooming magnolia trees. And every Sunday, in a lovely spot on the West Side adjacent to the American Museum of Natural History, the 79th Street Greenmarket features hydrangeas, ranunculus, primrose, and other container plants. On Saturdays during spring and summer, the Grand Army Plaza Greenmarket in Brooklyn hosts local growers. Summer pop-up markets at Rockefeller Center and Bryant Park offer country-style, hand-tied posies of regional wildflowers.

The Seventh Avenue branch of the classic New York deli Merci Market sells an impressive array of bright cut flowers, casually displayed in buckets at the front entrance. Gourmet shops such as Citarella and Fairway Markets throughout the city offer a remarkably sophisticated selection of roses, Asian lilies, and other imported flowers.

For travelers hurrying through Grand Central Terminal, Dahlia, a European-style flower stand, is conveniently located near the tracks and is well-stocked with super-fresh, high-quality, affordably priced tulips, daisies, hydrangeas, roses, and lilies. On the other side of the terminal, in the Grand Central Market, the flower department showcases long-stemmed roses and will create a custom bouquet on the spot.

For a fully immersive floral experience in Manhattan, venture out before daybreak to Chelsea and witness the almost-magical metamorphosis of West Twenty-Eighth Street into the ephemeral green oasis that is the New York City wholesale flower market. As the first rose-tinged hints of dawn brush the sky, a lush garden appears on either side of the street as flower and plant vendors transform the area, recalling stagehands setting a scene.

An arching canopy of tall, lacy ferns, sheltering palm trees, and spiral topiaries materializes as if from nowhere, enclosing the sidewalks in a verdant embrace and softening the harsh backdrop of angular steel-and-glass structures.

Twisted ficus, big-leafed fig trees, flowering branches, walls of ivy, and pillars of arborvitae are organized into a dense, protective chorus line, muffling the traffic noise and filling the pedestrian walkways with a cool freshness.

At the base of this leafy promenade, an avalanche of potted plants, annuals, and foliage spills out, tumbling onto and burying the rough concrete in a living mantle of color and scent. Trays of succulents and daisies and cyclamen add rainbow shades and texture. In late summer, a vibrant spectrum of paper-wrapped dahlias and zinnias cascades across the sidewalk and overflows into the street, tempting early commuters to select a cheerful bouquet on their way to work.

Inside the shops, the freshest and most glorious blooms from around the world are arrayed in a petaled explosion. Late winter and spring bring intoxicatingly fragrant narcissus and hyacinths, neon parrot tulips, pristine snowdrops, ruffled ranunculus, and branches of lilac and pussy willow. Rows of frilly sweet peas in myriad pastel hues, resembling tulle ballet skirts, fill the shelves. And year-round you'll be delighted by roses, hydrangeas, and even peonies. Certain merchants sell only to the trade, but many welcome new visitors and flower lovers.

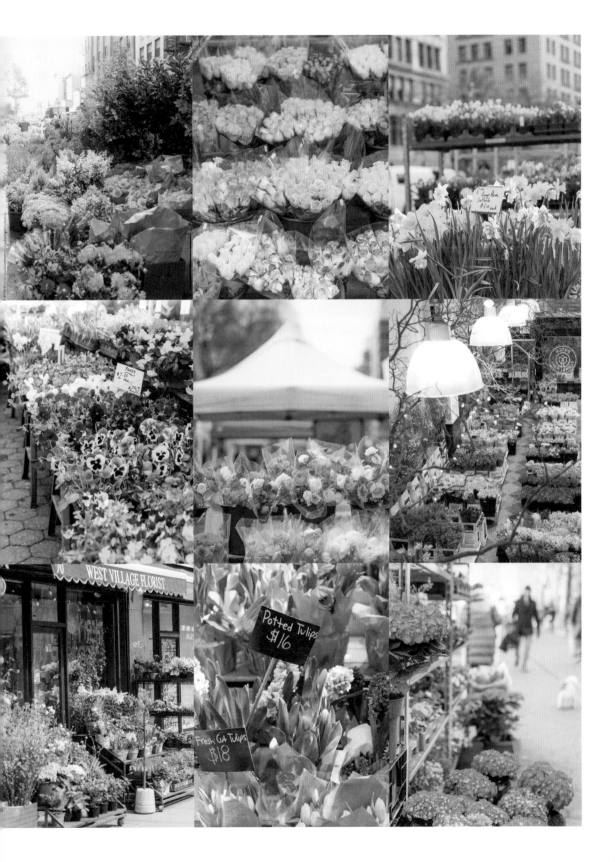

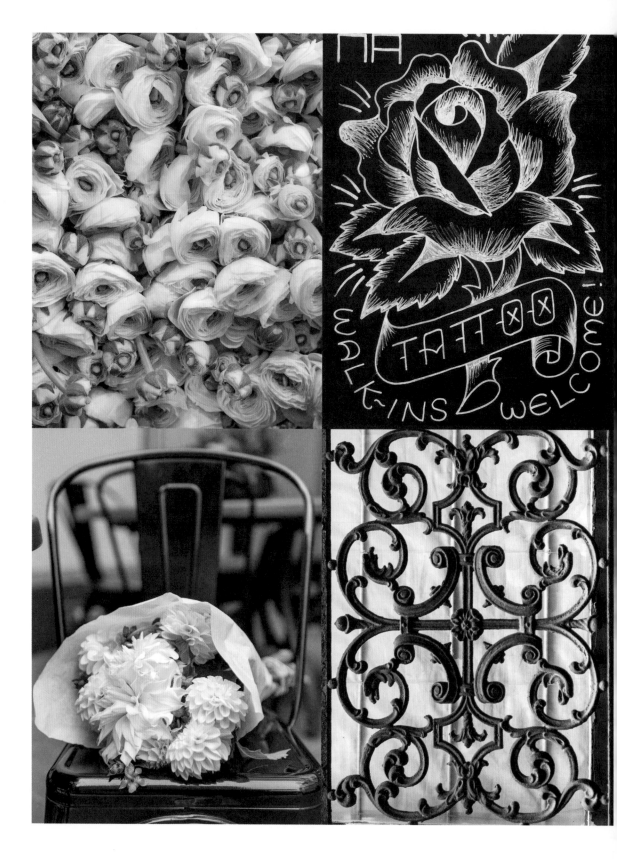

As a treat, you might also take yourself on a bloom-filled adventure to your local market. Wander around and let the flowers seduce you in their own unique ways. Some will speak to you more than others, depending on your style, taste, and environment. Match the flowers to your mood or to the mood you'd like to create. Feeling nostalgic? Gather up a handful of sweet peas, inhale deeply, and at once be transported to childhood days in your grandmother's garden. Envisioning elegance and glamour? Calla lilies and orchids will set a stylish scene. Sunflowers, dahlias, and zinnias are bold and fearless, but for classic romance choose roses, ranunculus, and peonies.

A simple bowl of richly hued and deeply scented roses in a home or office can inspire creativity, evoke cherished memories, and reduce stress. Late-summer dahlias, abundant in New York City throughout August and September, can brighten an apartment window, in decorative contrast to the skyscrapers and water towers beyond. And for an emotional boost, surely there is no more potent mood enhancer than a vase of luscious peonies.

Flowers and shrubs in an urban environment provide a vital, tactile, personal connection to nature. Whether you're a resident of or visitor to New York City, fresh flowers and plants are a necessary "luxury" item for you. Indulge in them for your office, kitchen windowsill, hotel room, fire escape, or terrace. Surprise a coworker or coffee date with a few ribbon-wrapped rosebuds, or a hostess with a small terrarium instead of the usual bottle of wine. A floral arrangement will immediately soften and brighten any space, and will always bring a spark of joy or a smile of friendliness.

And ultimately, flowers generously and humbly offer New Yorkers beautiful reminders of nature's therapeutic power.

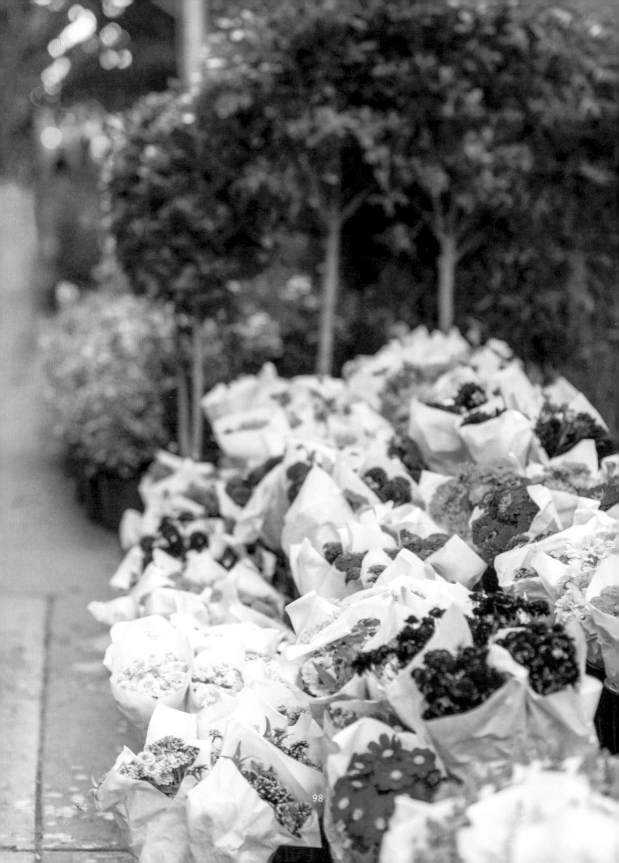

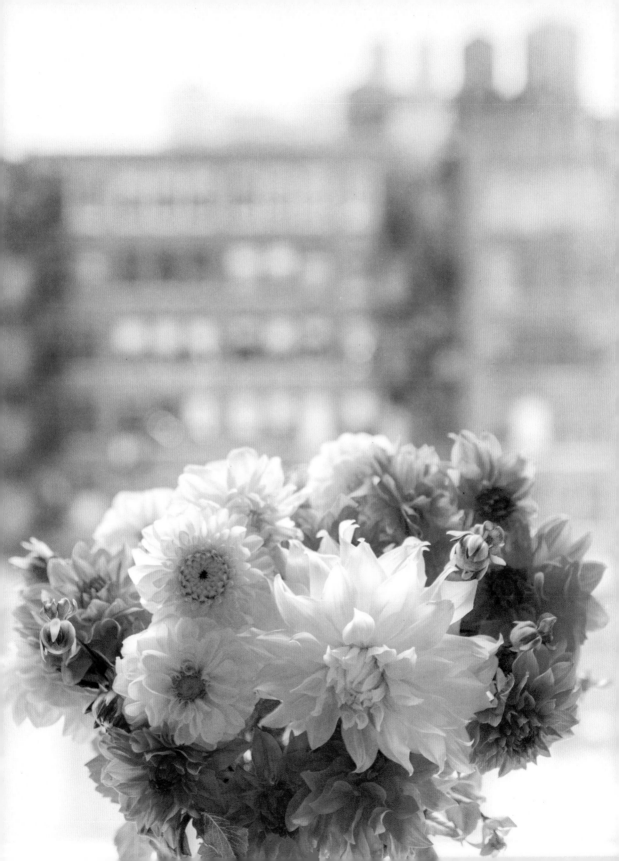

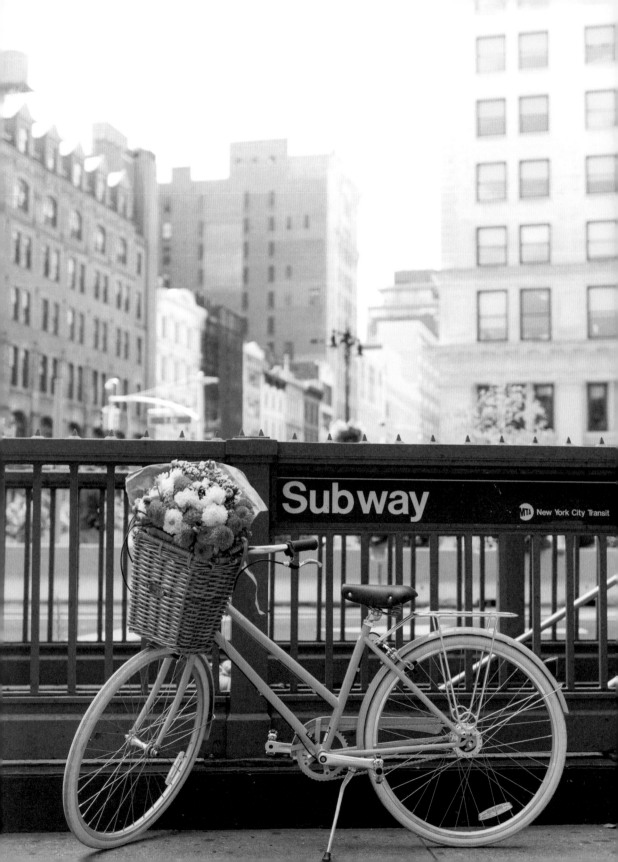

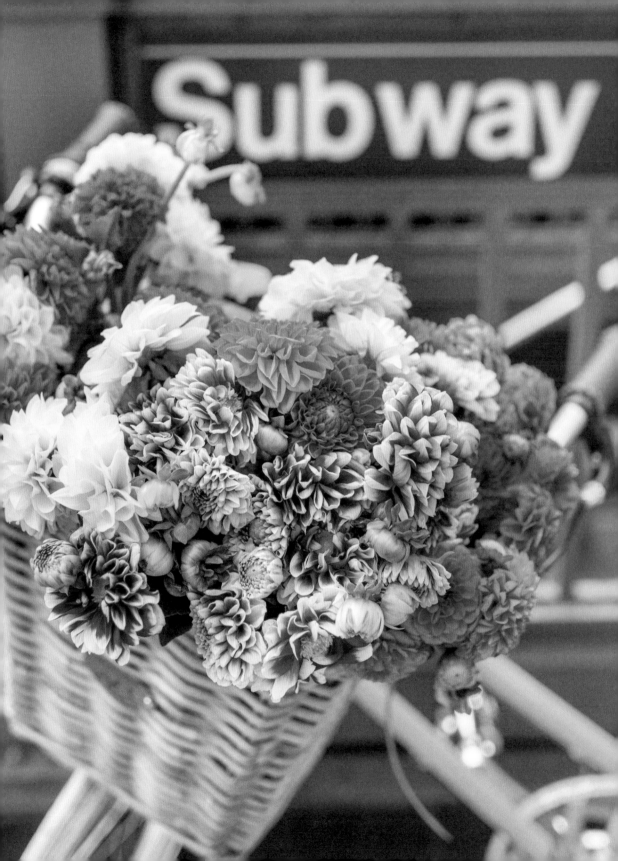

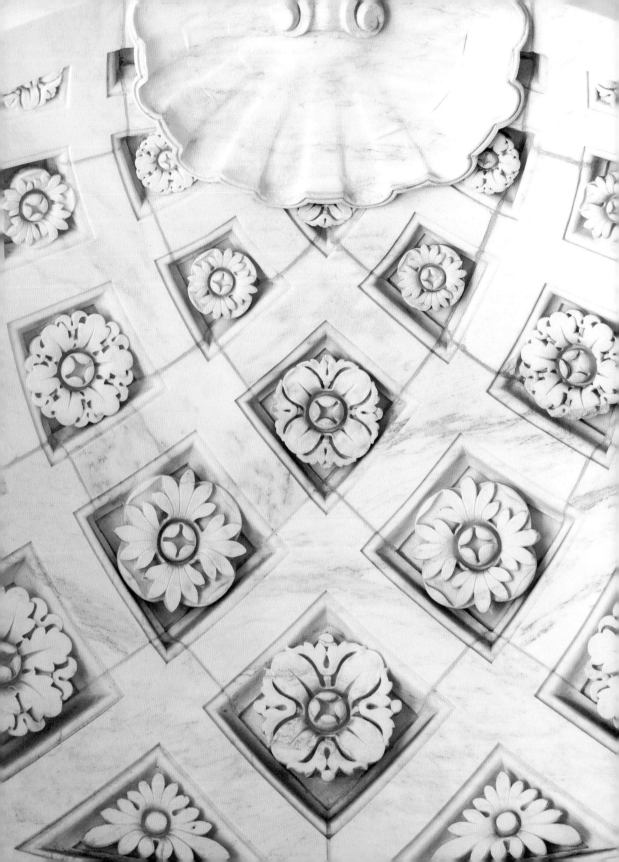

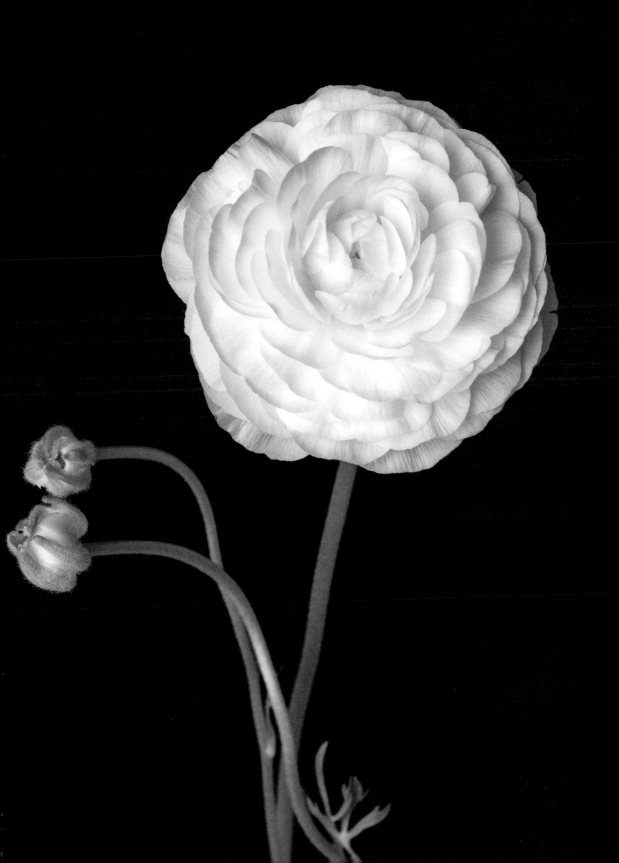

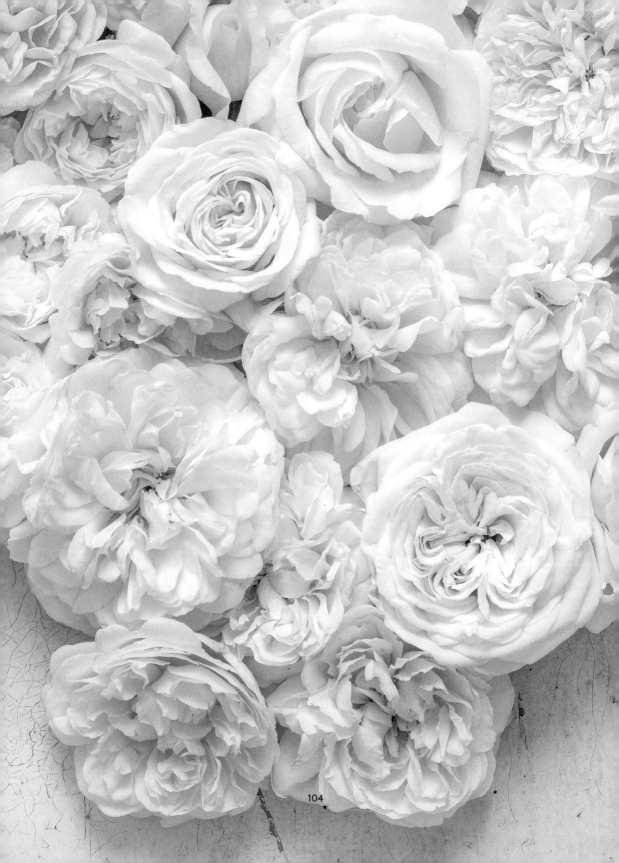

FLOWER

CASKODEN

THE
LOST
HEIR

HENTY

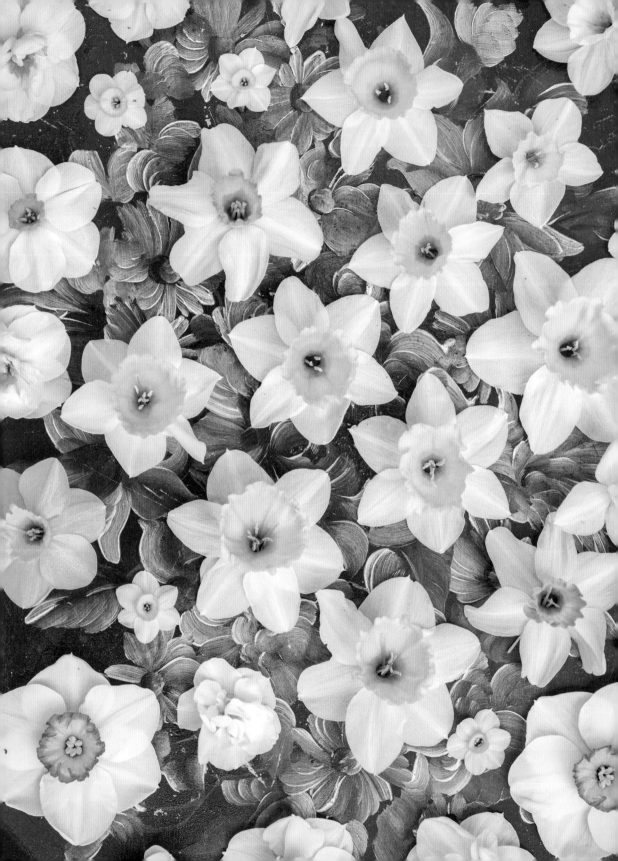

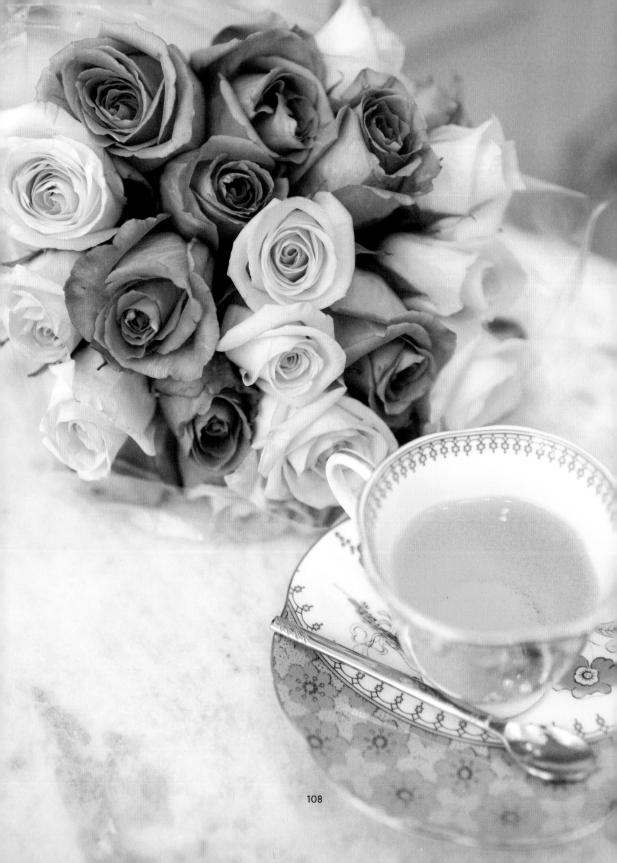

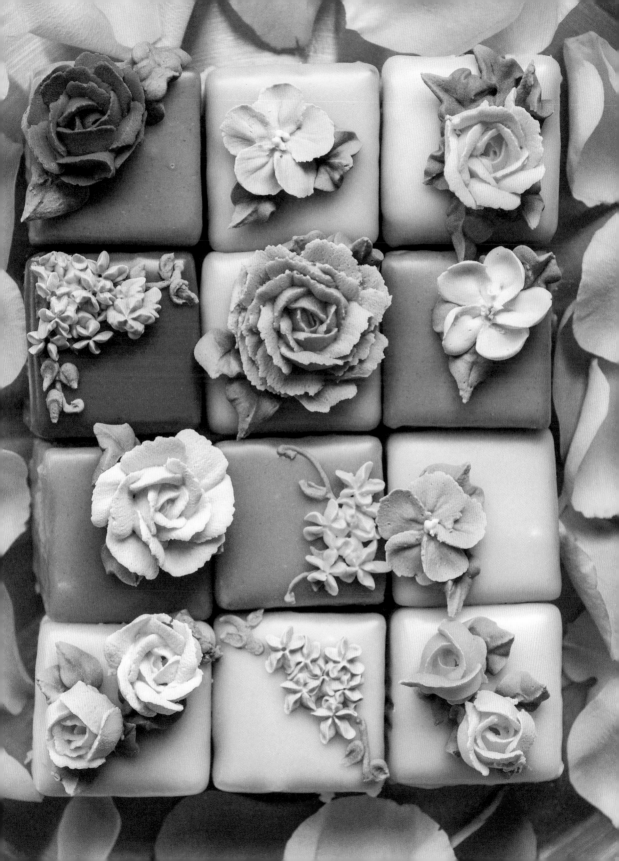

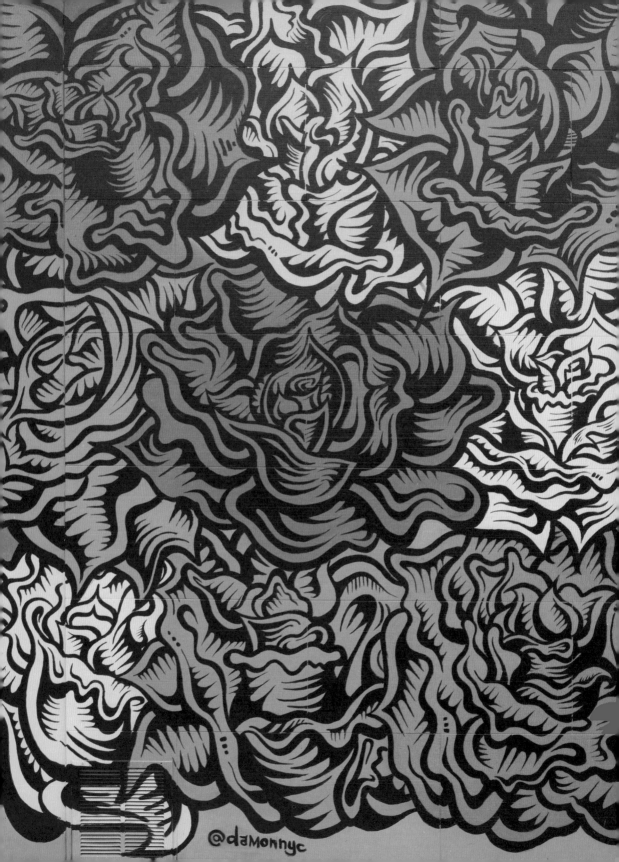

@damonnyc

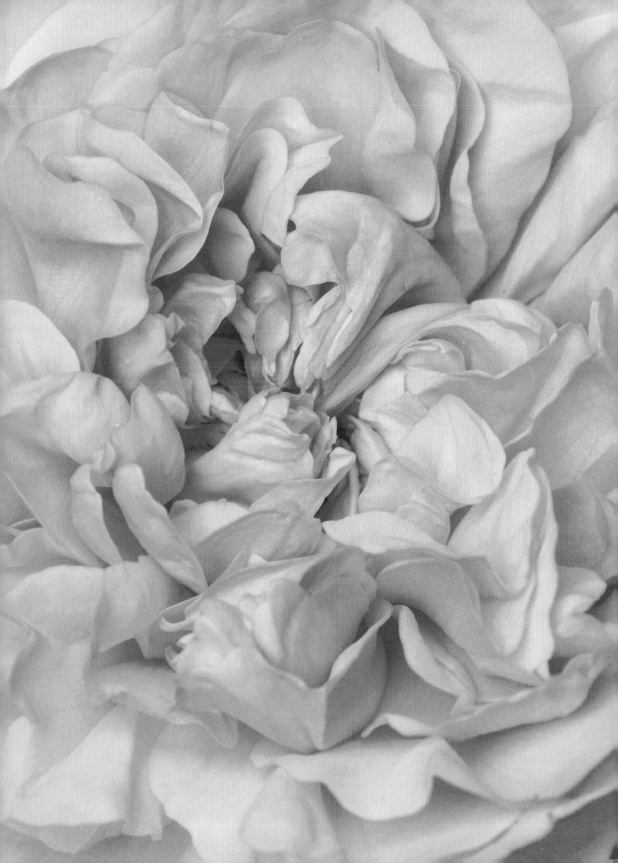

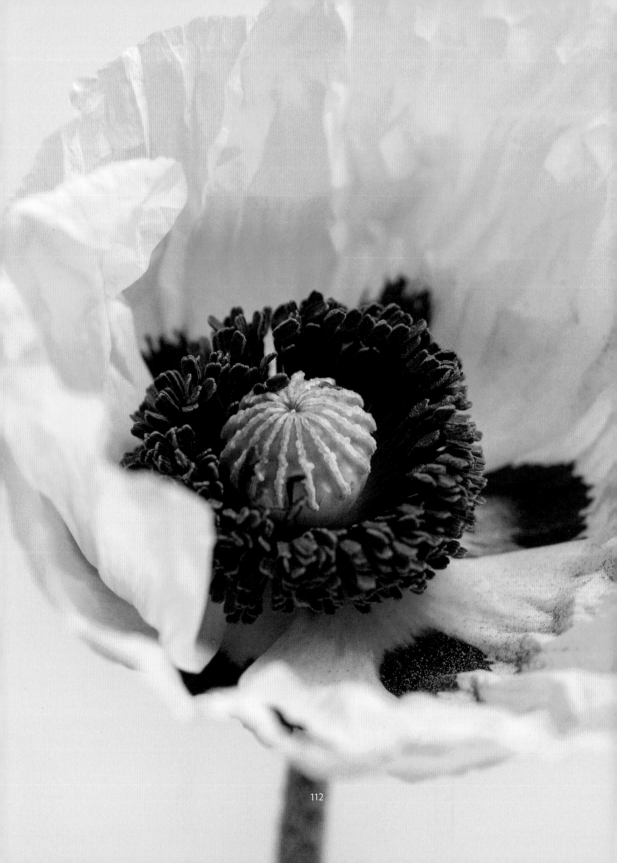

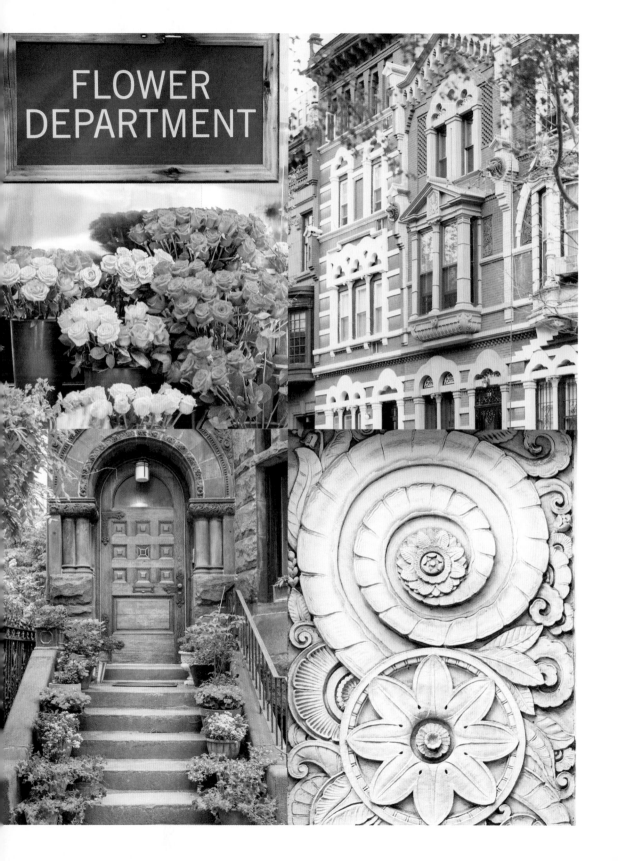

FLOWER
DEPARTMENT

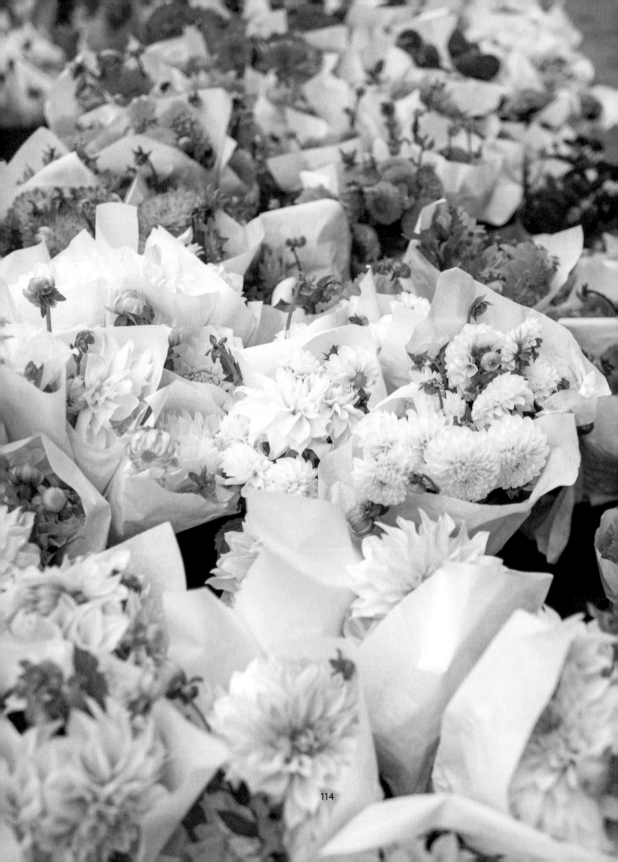

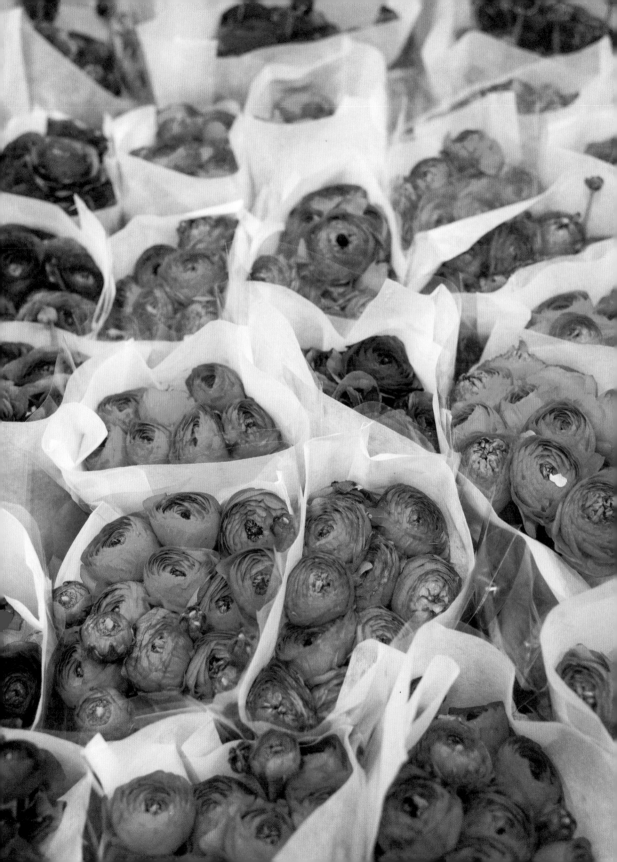

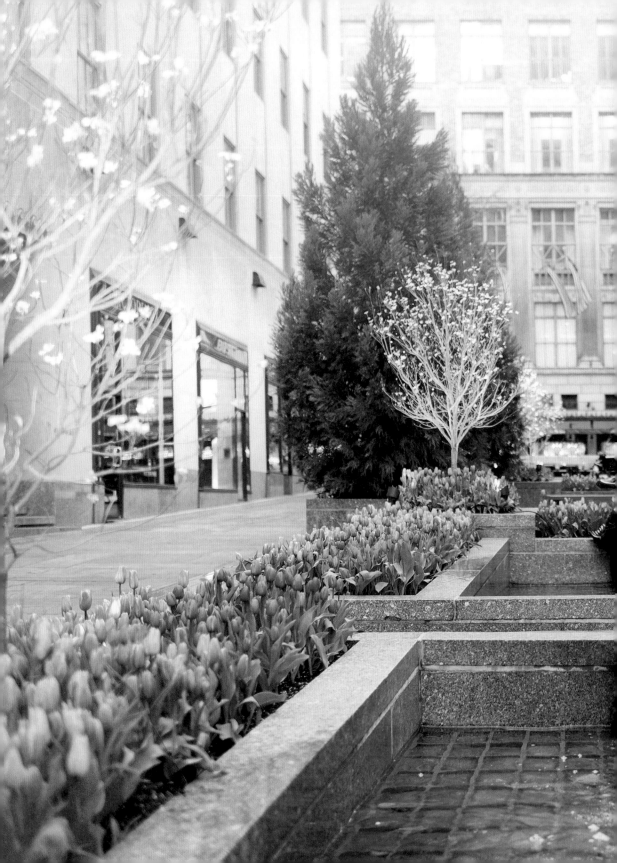

FLORAL DISPLAYS

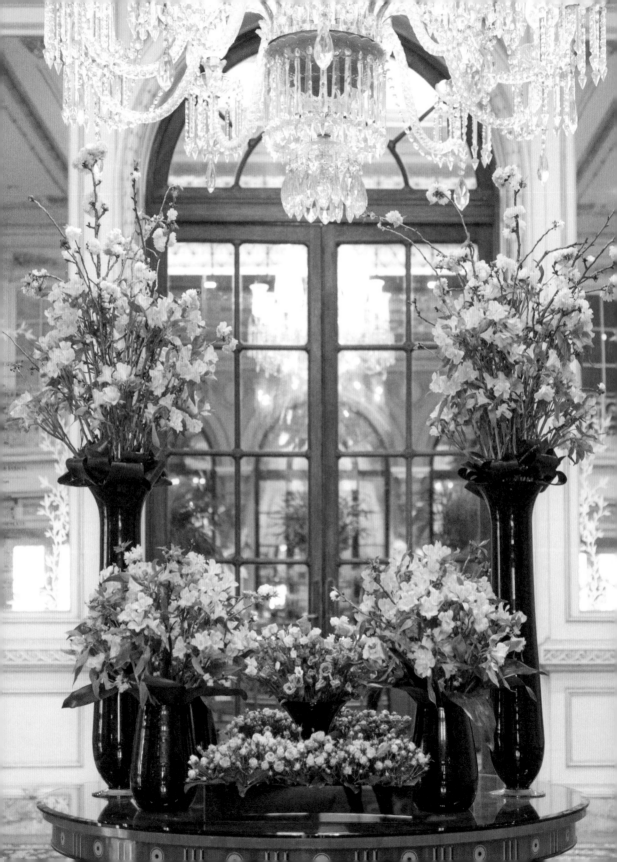

New Yorkers take their floral displays very seriously, and, as befits the city's grand scale, they are world-renowned and spectacular. Many are unique to New York and contribute to defining the city's botanical heritage.

The sumptuous installations in luxury hotel lobbies, such as those at the Plaza and the Peninsula, are legendary, with top florists challenging themselves to outdo each previous array in opulence and grandeur. It's not necessary to be staying in the hotels—the displays are meant to be seen and experienced by all. An afternoon tea or an evening cocktail in the Palm Court will enable you to enjoy them as the hotel guests do.

The huge urns in the Metropolitan Museum of Art entrance hall visually echo artworks in the collection that were created in New York, including an inlaid secretary desk, made by Herter Brothers, and an iridescent-glass mosaic of a garden scene, designed by Louis Comfort Tiffany. Both can be visited in the American Wing.

On show at the annual Easter Parade on the Avenue—Fifth Avenue, that is, of course—you'll find one of the most festive displays of flowery extravagance in the city. The long-standing tradition of the parade began in the 1870s as a promenade for the "swells" to show off new finery and splendid blossom-strewn hats. The event inspired the popular Irving Berlin song and later, the Fred Astaire film. Less a formal parade now than a jovial gathering that congregates mostly around Forty-Ninth Street, participants' outlandish hats and outfits (and even costumed pets) are magnets for photographers and families out for an afternoon of fun and laughter. All are welcome, and the more colorful, birdcage-embellished, and towering the headdress, the better.

Nearby, the changing floral displays at Rockefeller Center draw tourists and locals in anticipation and appreciation. From Easter bunnies, tulips, and daffodils in spring to roses and hydrangeas in summer, and mums in autumn, the kaleidoscope of plantings frames the tiered fountains. The sea of yellow daffodils in April, at the base of the flags of the world, is a beautiful and poignant tribute in memory of September 11.

Park Avenue, the wide boulevard with double lanes of traffic running nearly the length of Manhattan, is impressive at any time of year. But in mid-spring, massive plantings of tulips at the bases of abundantly blooming cherry trees on the center median make it a much-photographed floral destination.

A magical experience awaits at Herald Square in late March, as the annual Flower Show at Macy's flagship store literally takes one's breath away with its magnificence. The interior is transformed into a luscious, living wonderland made entirely of fresh flowers, shrubs, arrangements, bouquets, and plantings that create tableaux, drape over archways, and hang from canopies. White orchids, hot-pink azaleas, purple rhododendrons, fragrant hyacinths, animal-shaped topiaries, and live spring-blooming trees build a fantasy world. The theme changes each year, but the show is always enchanting and staggeringly impressive.

The New York Botanical Garden's Orchid Show is another fixture on the yearly floral event calendar. Installed in the soaring Enid A. Haupt Conservatory, the rambling exhibit meanders through the hothouse environment, showcasing a lavish presentation of hundreds of rare and beautiful varieties gathered from all over the globe. For the orchid enthusiast, it's an enlightening and memorable experience.

Shopfronts playfully adorned with cascading garlands of colorful silk blooms can be seen more and more at clothing boutiques and home goods stores in the Village and Lower East Side, echoing a delightful craze that has until recently been associated mostly with London.

And on streets and avenues everywhere, in all seasons but winter, imaginative plantings embellish and enliven public and private tree beds, sidewalk containers, urns, bicycle baskets, balconies, and stoops, creating perhaps the largest urban gardenscape in the world, New York style.

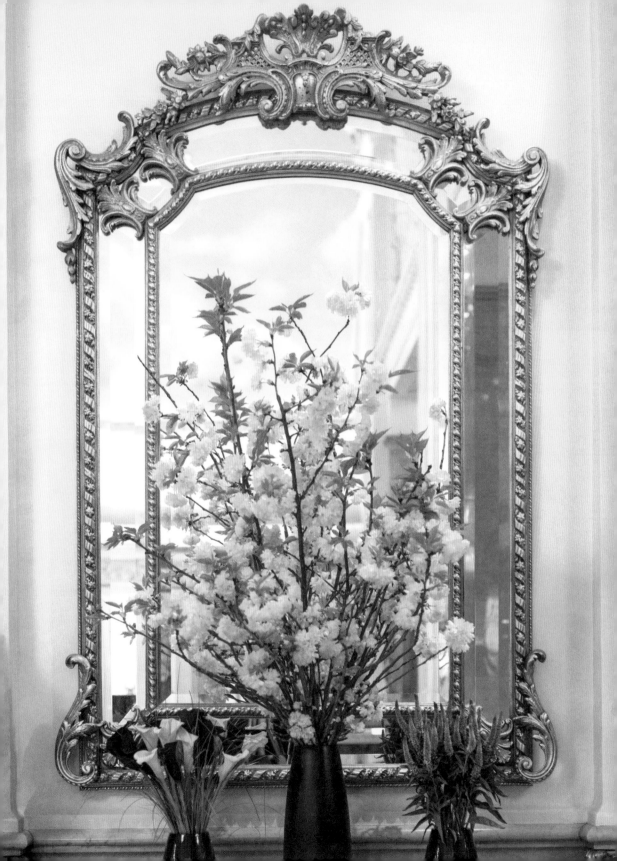

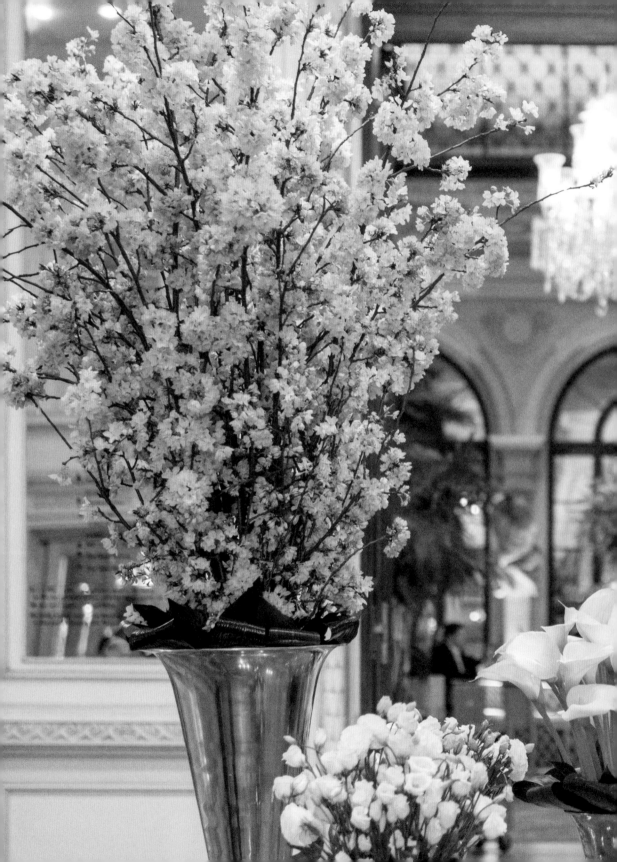

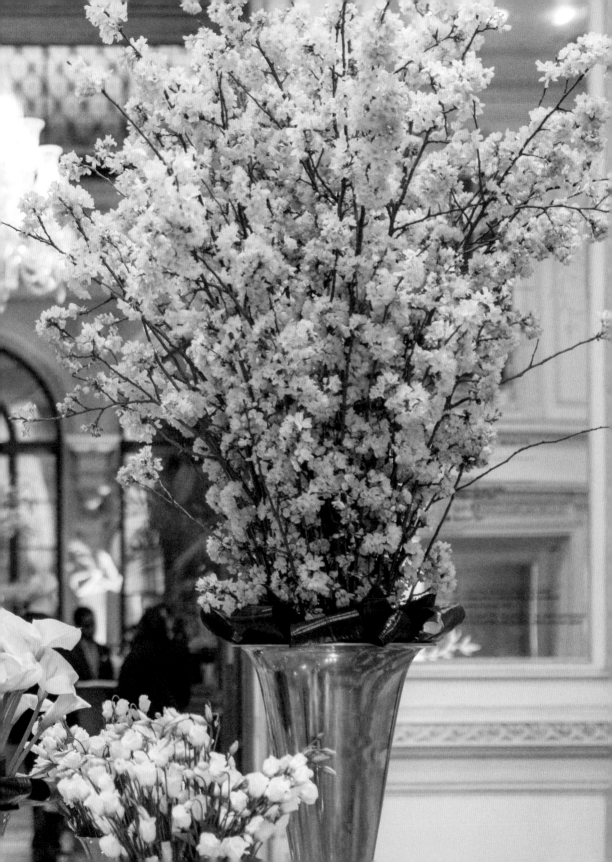

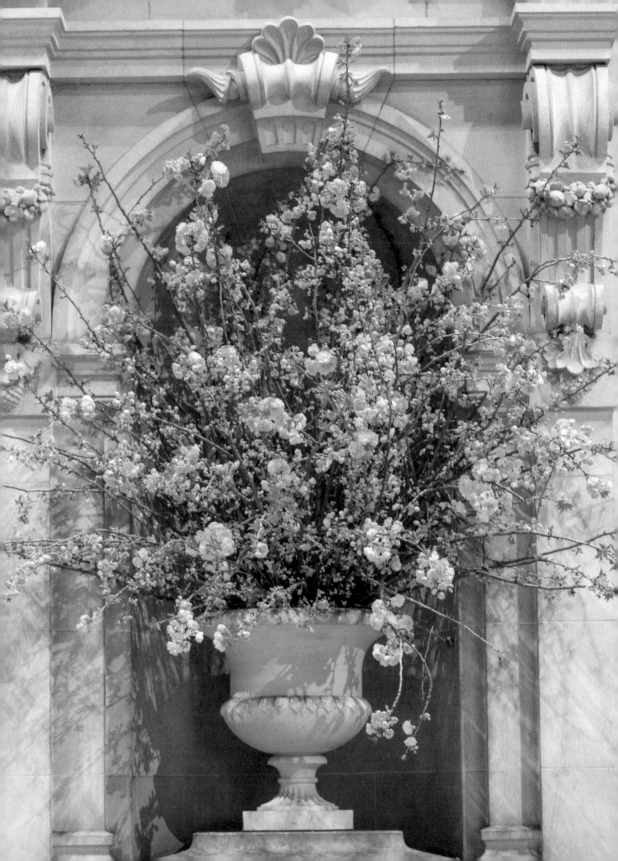

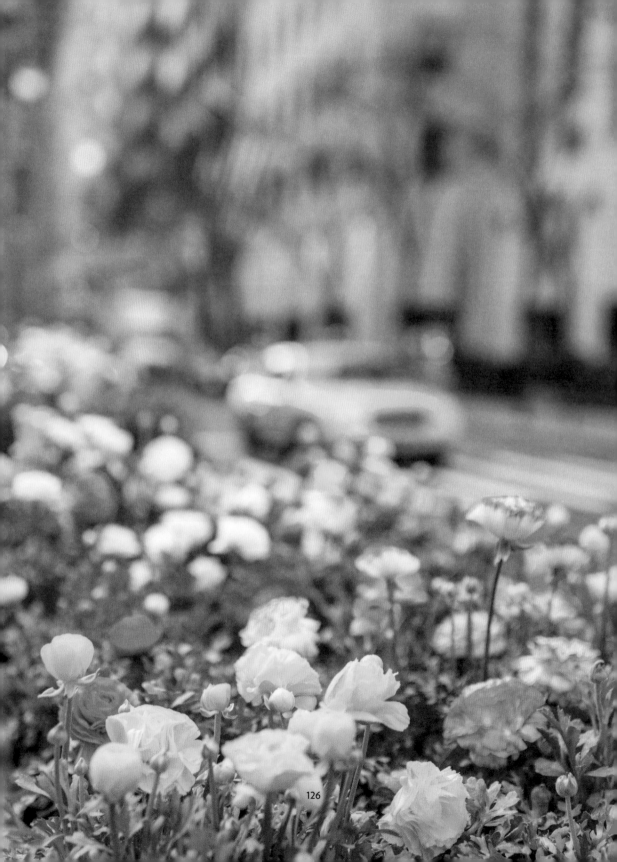

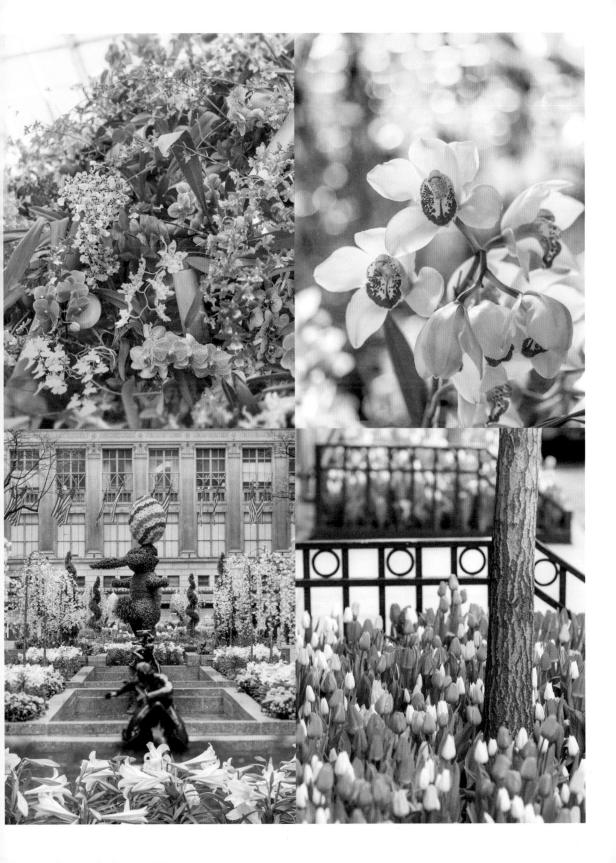

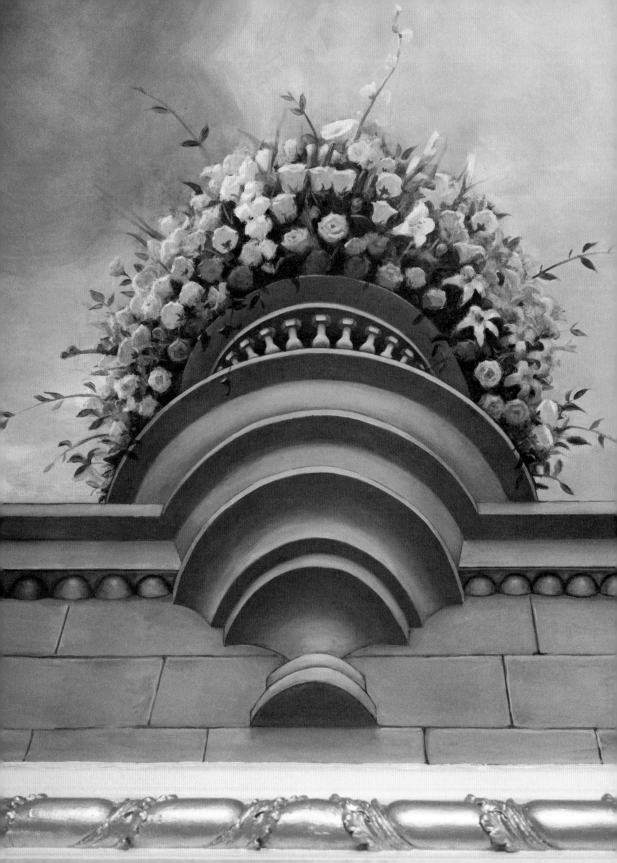

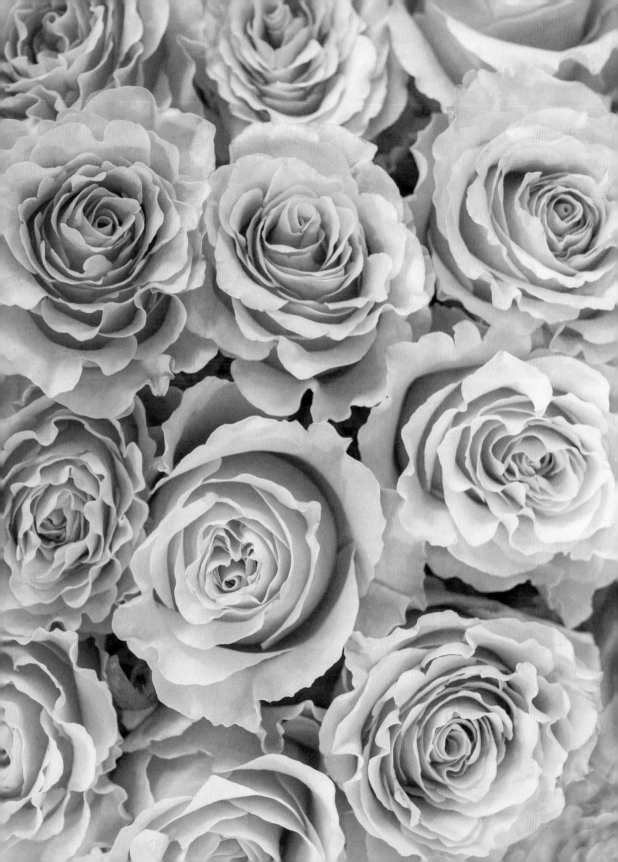

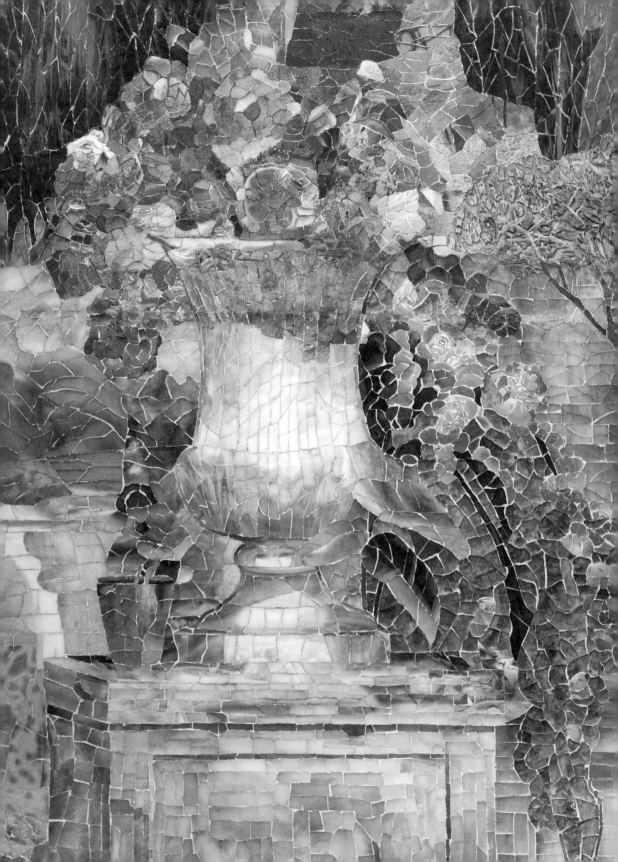

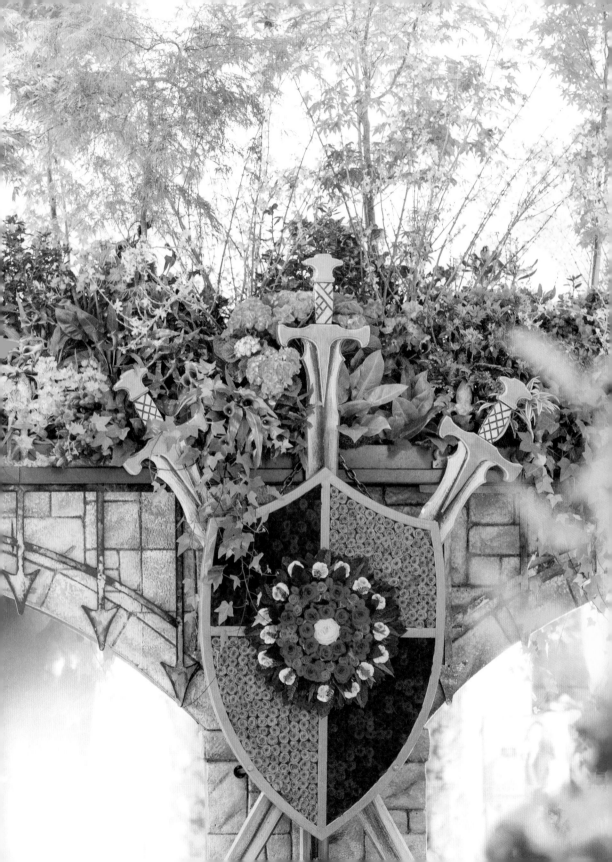

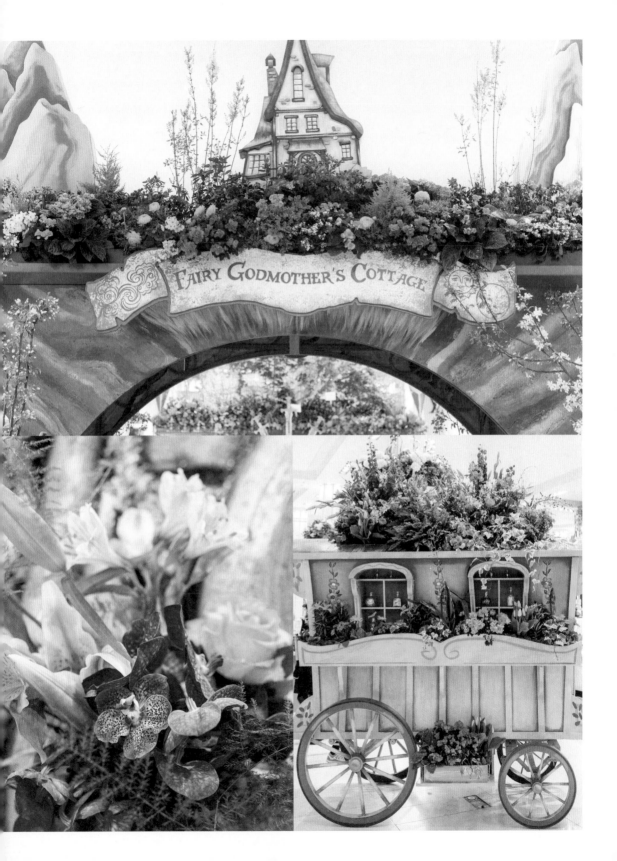

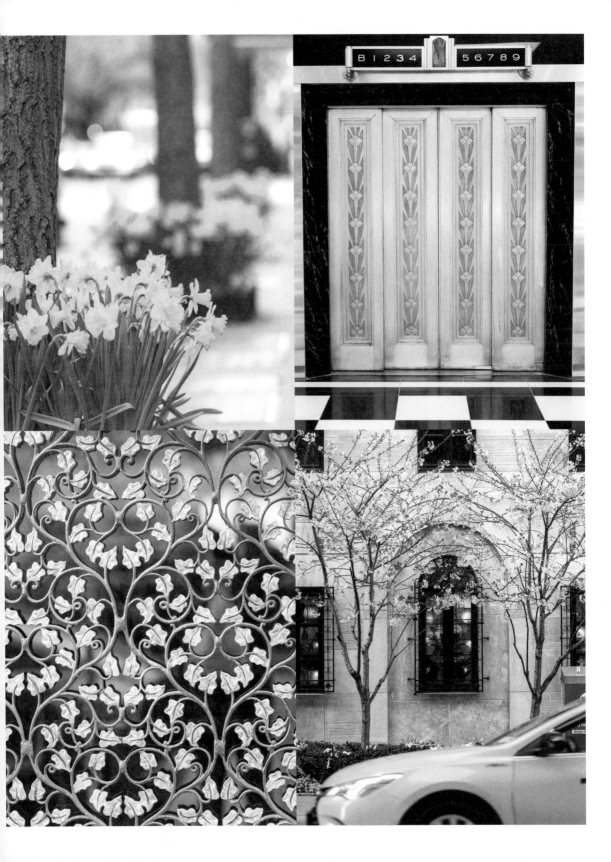

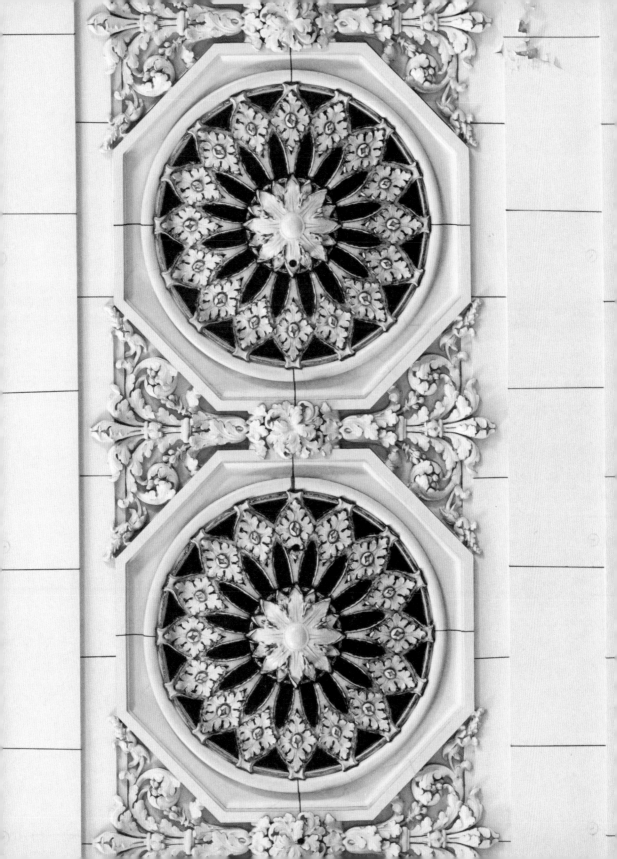

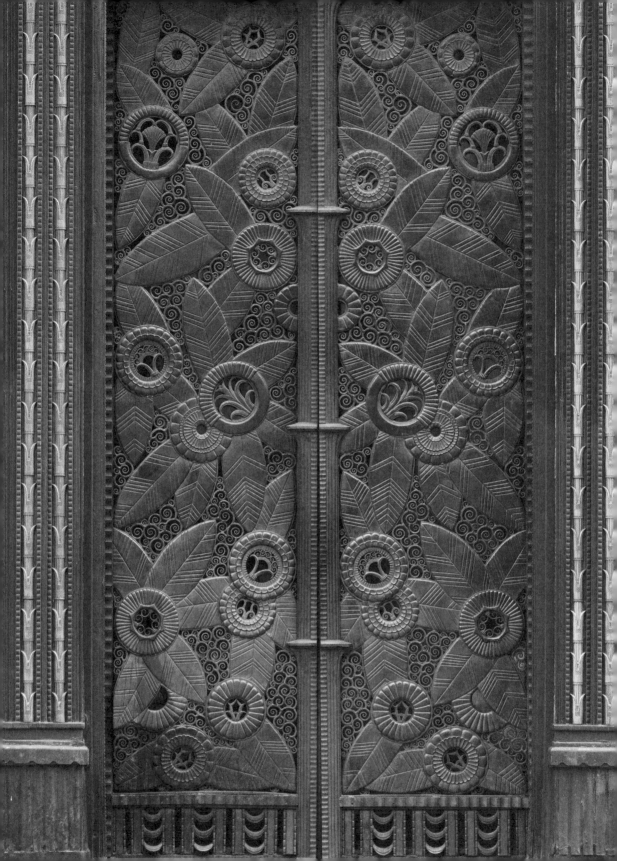

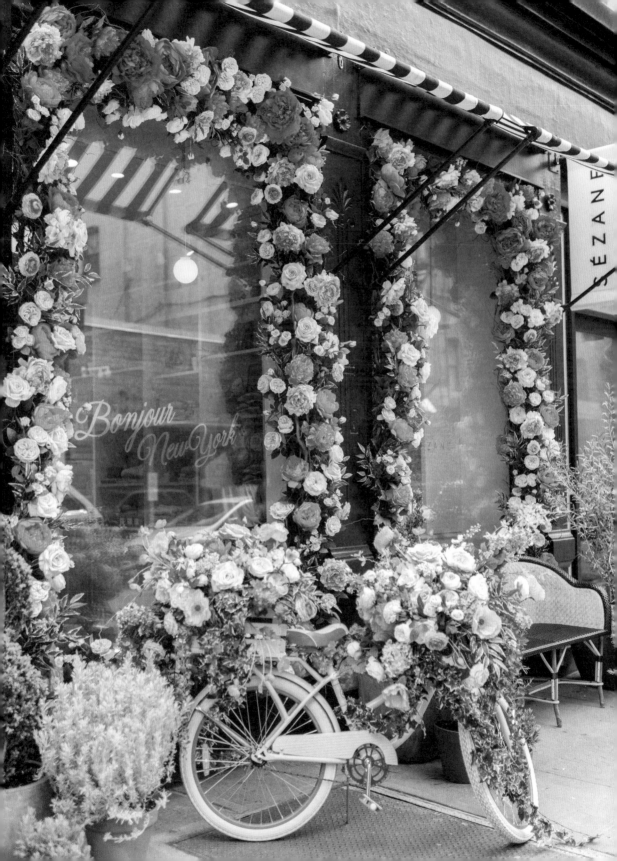

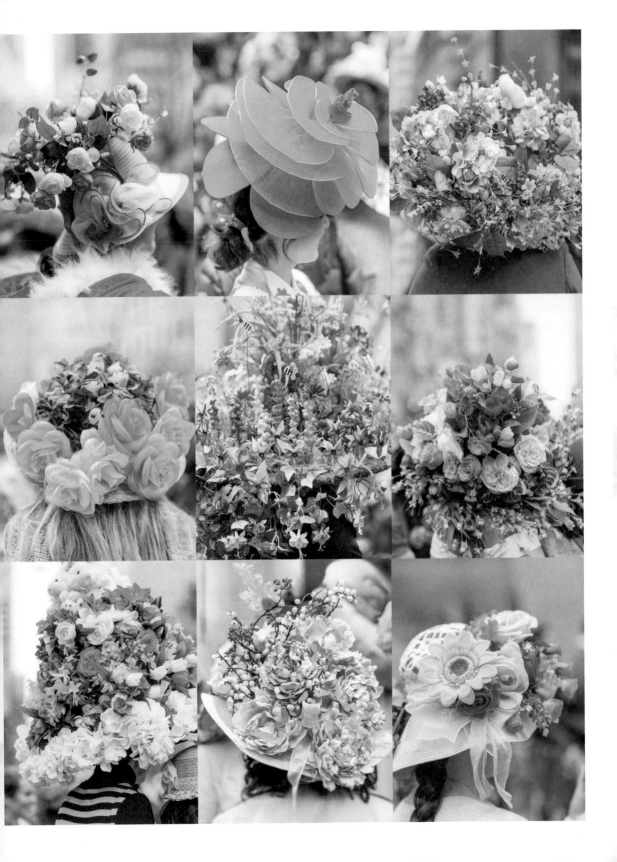

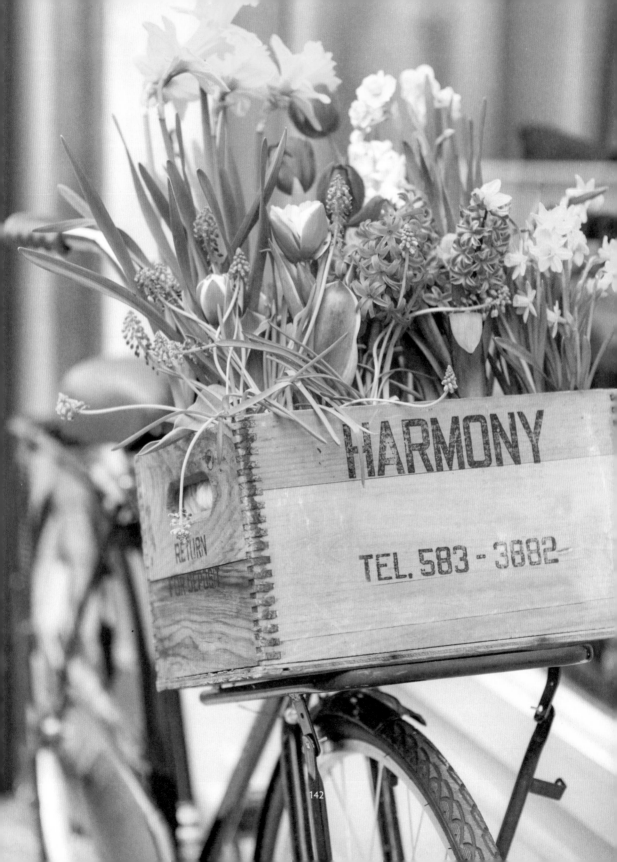

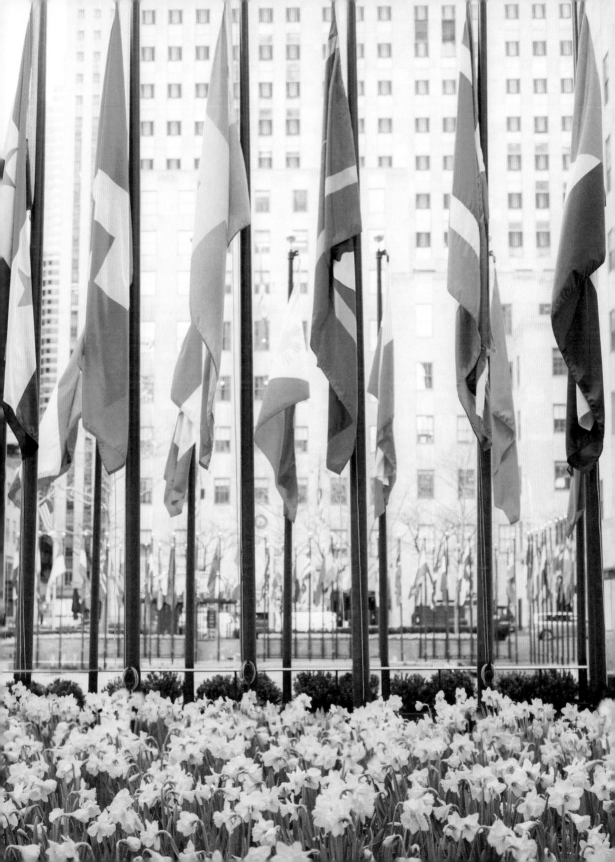

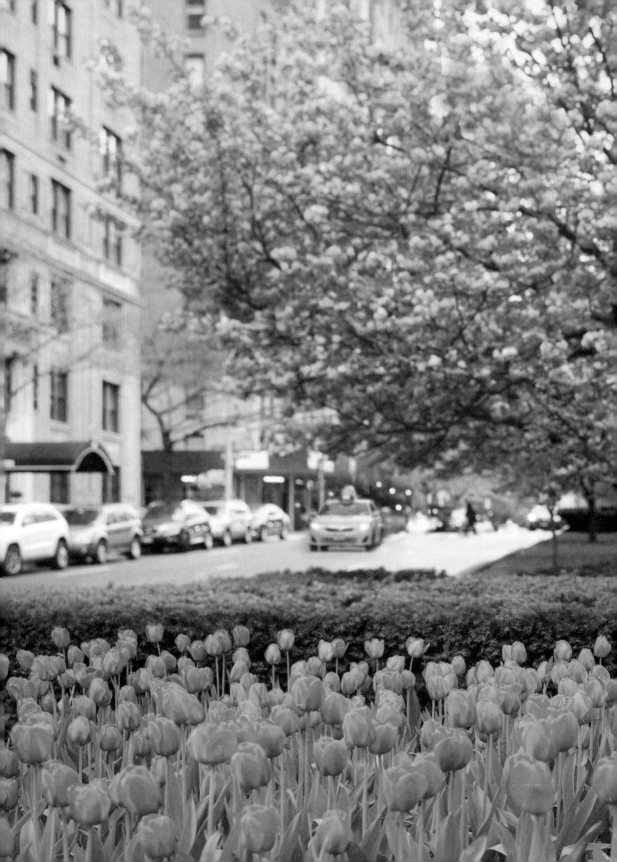

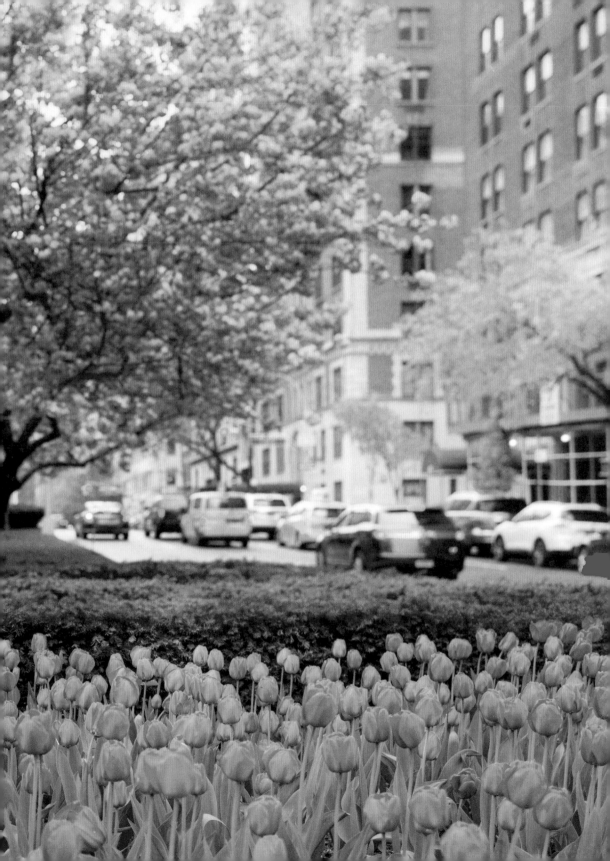

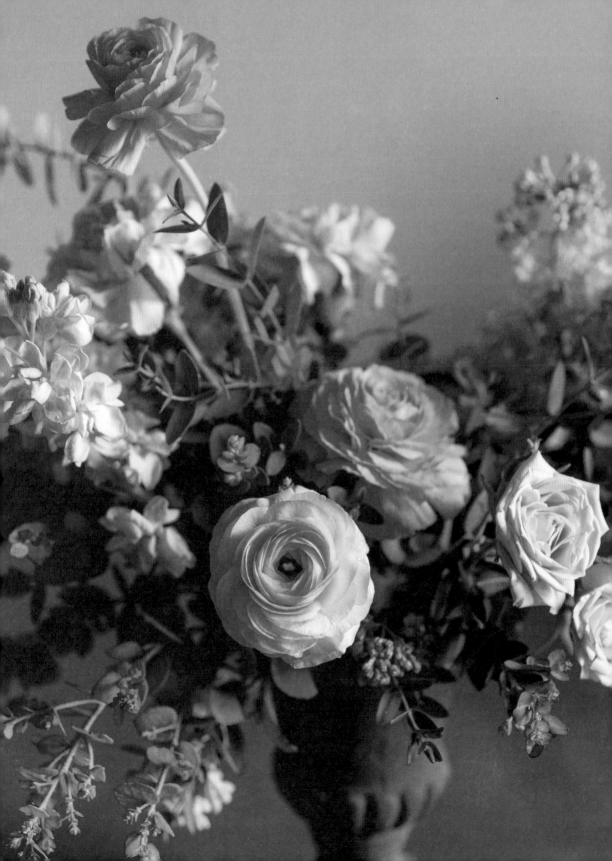

CREATING YOUR OWN NEW YORK CITY-STYLE BOUQUET

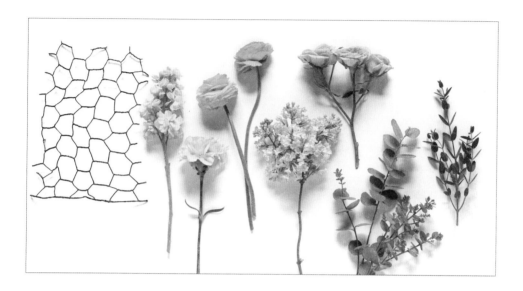

Following these simple steps, and with readily available supplies, you can create your own beautiful arrangement, inspired by the work of popular New York City floral studios.

You will need:

1. A 12-inch (30-cm) square of chicken wire cut from a roll using tin snips. (Tip: Do not use gardening clippers to cut wire, as it will dull them.)

2. Thick gardening gloves to wear while shaping the chicken wire.

3. A suitable decorative container, such as an urn or shapely vase. Ensure that it will hold water.

4. Floral clippers strong enough to cut stems.

5. Flowers and foliage:

 a. Choose three or four featured flowers in complementary colors. Here we've used blush lilac, peach ranunculus, golden-yellow spray roses, pale pink stock, and pale yellow carnations, all of which are available in season at almost any flower market or grocery store. You could also use peonies, narcissus, sweet peas, mums, dahlias, gerbera daisies, garden roses, snapdragons, or any other pretty cut flowers. Consider shape, texture, color, and fragrance.

 b. Choose up to three different types of cut foliage in colors and textures that will contrast with and complement your main flowers. Foliage will form the structure and foundation of your arrangement, so don't choose limp or flimsy varieties. We've selected two kinds of eucalyptus.

Steps:

1. Prepare all flowers and foliage by stripping off leaves that would sit below water level in the container. Remove any thorns from roses. Cut the stems at an angle and put them in fresh water while you prepare the container with the chicken wire and arrange the foliage.

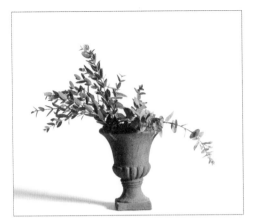

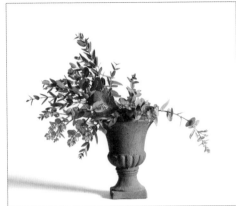

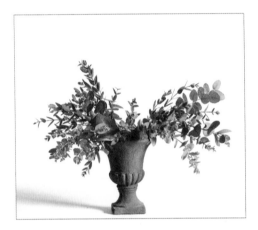

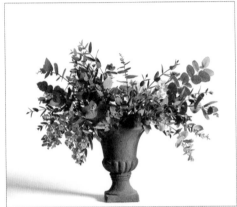

2. Wearing gloves, crush the chicken wire into a loose ball, taking care not to poke yourself on the sharp edges.

3. Place the chicken wire into the container and fill with water. Add floral preservative to the water to help to prolong the life and freshness of the flowers.

4. Select nice-looking stems of each different foliage plant. Cut to the length appropriate for the size and shape of arrangement you envision. Hold them up before you place them in the container to ensure they are not too long. Trim as needed.

5. Place the first bunch in the left side of the container, as shown, securing the stems in the chicken wire. Select further stems and arrange on the right. Leave some negative space off center, for interest. Add further foliage in front to create a pleasing shape and cover the edge of the container.

6. Continue to add foliage until you have a good foundation and range of colors and textures. Ensure all the stems are stable and securely held in the chicken wire.

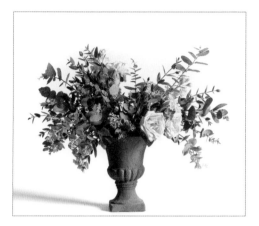

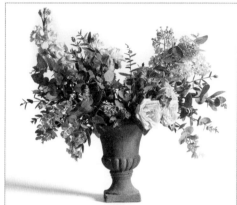

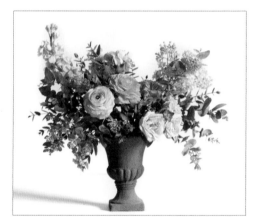

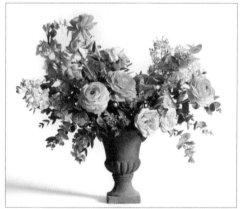

7. Choose your first featured flowers, preferably round flowers (ours are spray roses), and trim to a length that will allow them to nestle in among the foliage.

8. Place more featured flowers in a prominent spot, clustering them together in threes or fives (uneven numbers create interest). Add several bunches, as shown. Ensure they are secured in position and will not droop or fall out.

9. Begin to add the secondary flowers (we've used stock) to give color and more texture. Place them on the sides and behind the first featured flowers.

10. Add the third variety of flower (ours are ranunculus) at varying heights, for interest and movement.

11. Look at your arrangement from all angles to check for gaps or holes. Fill any gaps with flowers, trimming the stems as needed.

12. Display in a location where it will bring you joy, and be admired and appreciated. Be sure to check the water level several times a day and change the water daily.

FIELD GUIDE TO COMMON SPRING-BLOOMING TREES AND SHRUBS IN NEW YORK CITY

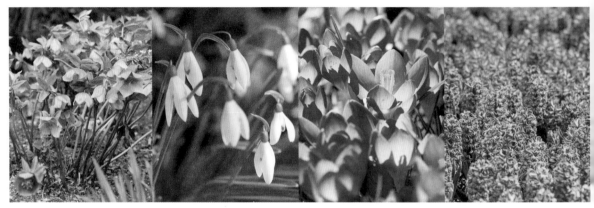

Hellebore
(*Helleborus*)

Snowdrop
(*Galanthus nivalis*)

Crocus
(*Crocus*)

Hyacinth
(*Hyacinthus*)

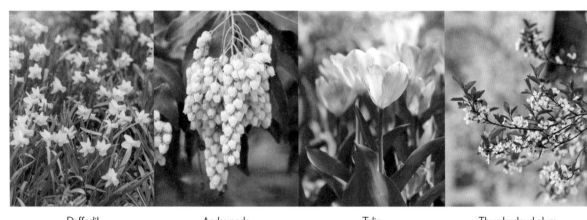

Daffodil
(*Narcissus*)

Andromeda
(*Pieris* or *Andromeda*)

Tulip
(*Tulipa*)

Thundercloud plum
(*Prunus cerasifera* 'Thundercloud')

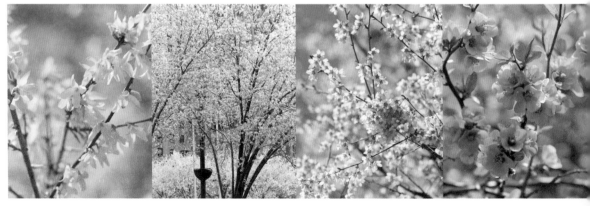

Border forsythia
(*Forsythia × intermedia*)

Callery pear
(Pyrus calleryana)

Okame cherry
(*Prunus* 'Okame')

Flowering quince
(*Chaenomeles*)

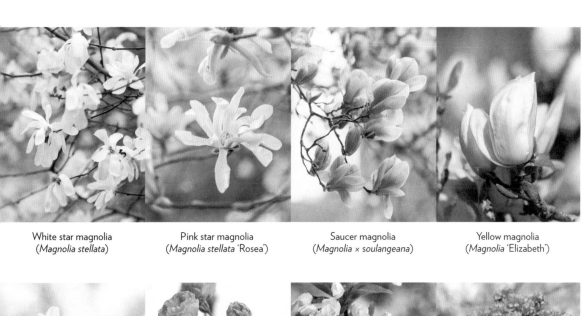

White star magnolia
(*Magnolia stellata*)

Pink star magnolia
(*Magnolia stellata* 'Rosea')

Saucer magnolia
(*Magnolia × soulangeana*)

Yellow magnolia
(*Magnolia* 'Elizabeth')

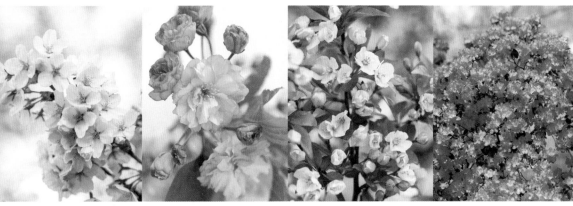

Yoshino cherry
(*Prunus × yedoensis*)

Kwanzan (or Kanzan) cherry
(*Prunus serrulata* 'Kwanzan')

Flowering crab apple
(*Malus spectabilis*)

Azalea
(*Rhododendron*)

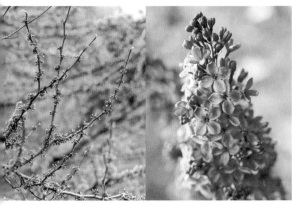

Eastern redbud
(*Cercis canadensis*)

Lilac
(*Syringa vulgaris*)

Dogwood
(*Cornus*)

Chinese wisteria
(*Wisteria sinensis*)

SPRING TOUR OF BLOSSOMS AND BLOOMS

This essential guide will introduce the dedicated blossom hunter to numerous glorious and showy scenes throughout New York City. For a comprehensive list of blooms in Central Park, by season and location, consult the excellent Central Park Conservancy website www.centralparknyc.org/things-to-see-and-do/bloom-guide.

Where: Central Park
When: Early to mid-March
Bright forsythia dot the park with yellow plumes. Hellebores and snowdrops can be found throughout the grounds, inviting close inspection of their nodding, delicate beauty.

Late March to early April
Narcissus and star magnolias make their appearance and the earliest cherries begin.
White star magnolias appear near the Loeb Boathouse and on Bethesda Terrace.

Early to mid-April
Pink saucer magnolias bloom throughout the park, notably at Bethesda Terrace and in a small but photogenic grove framing the Obelisk, known as Cleopatra's Needle, on the terrace behind the Metropolitan Museum of Art.
Soft pink Yoshino cherry trees are best viewed on Cherry Hill, Pilgrim Hill, and on the east side of the Reservoir.

Mid- to late April
White Mount Fuji and pink Kwanzan cherry trees can be found throughout the park, notably on the west side of the Reservoir.
Some beautiful yellow magnolias bloom in late April along the path from Bethesda Terrace to Bow Bridge.

Where: Conservatory Garden, Central Park
When: Late April

Wander through the impressive Vanderbilt Gate to view the dramatic twin rows of pink and white crab apple trees—one of the most stunning displays in the city.

Where: New York Botanical Garden
When: Early March to mid-April
The annual Orchid Show takes place in the Enid A. Haupt Conservatory.

Mid- to late April
Daffodil Hill becomes awash in yellow and white from hundreds of thousands of daffodil bulbs, shaded by delicate crab apple blossoms.
The conservatory itself is framed by gently arching cherry trees in bloom.

Early May to mid-June
The Matelich Anniversary Peony Collection outside the conservatory showcases more than 150 varieties.

Late May to the end of summer
The Peggy Rockefeller Rose Garden is a rose lover's paradise.

Where: Brooklyn Botanic Garden
When: Late March to early April
View the ivory, yellow, pink, and rich purple of over a dozen varieties of magnolias on Magnolia Plaza.

Late April
The Kwanzan cherry trees take center stage at the Cherry Walk and Cherry Esplanade, the location of the annual Sakura Matsuri festival.

Late May to the end of summer
The Cranford Rose Garden is filled with hundreds of varieties that overpower the senses with fragrance and color.

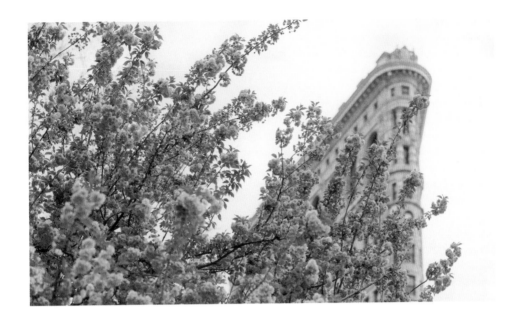

Where: Madison Square Park
When: Early to mid-April
Several huge Kwanzan cherries bloom around the park. The fragrant beds of daffodils, fritillarias, and tulips are the prettiest in the city and can be enjoyed from the many café tables and chairs. The park also has several notable plant collections, including beautiful redbud trees.

Where: Roosevelt Island
When: Early April
Yoshino cherry trees are in bloom at the southwest end of the island, which creates a delicate frame for the fabulous views from here of Manhattan and the Queensboro Bridge.

Late April
The Kwanzan cherry trees bloom, just north of the Yoshinos and nearer the tram station, but offer similarly beautiful views of Manhattan. Take the tram, in any case, for a unique transportation experience.

Where: The Frick Collection
When: Late March to early April
Stroll along the Fifth Avenue side of the museum, facing Central Park, for a view through the iron fence of several truly remarkable magnolia trees in bloom. Their perfection of form is a marvel.

Where: Carl Schurz Park
When: Late April
A lovely small grove of Kwanzan cherry trees bursts into bloom.

Where: Washington Square Park
When: Late April
Crab apple trees and Kwanzan cherry trees add bright bolts of color to this lively park.

Where: Bryant Park
When: Early April
Look for the beds and urns of dark blue hyacinths and yellow daffodils that are among the first to appear anywhere in the city.

Where: Citywide
When: Early to mid-April
Fluffy white Callery pear blossoms are one of the first signs of spring.

SELECTED ADDRESSES

A comprehensive list of my favorite floral locations is beyond the scope of this section, but here is a very good basic starting point as you begin your exploration of New York's floral treasures.

PARKS AND GARDENS

Central Park
Between Central Park West and Fifth Avenue, from Central Park South (Fifty-Ninth Street) to Central Park North (110th Street)

Possibly the best-known and most beloved park in the world, it is a glorious haven in spring. Highlights include the magnolia grove framing Cleopatra's Needle on the terrace near the Metropolitan Museum of Art; Cherry Hill; Pilgrim Hill; the cherry trees on the east and west sides of the Reservoir; and the delicate historical blooms of the Shakespeare Garden.

Conservatory Garden, Central Park
Main entrance at 402 Fifth Avenue, between 104th and 105th Streets

The only formal garden in Central Park, this calm and restorative space, an officially designated Quiet Zone, is among my favorites. Enter through the grand Vanderbilt Gate, and you realize that you have arrived at an exceptional, enchanting location. Its magnificent twin avenues of pink and white crab apple trees are breathtaking when in full bloom.

New York Botanical Garden
Main entrance at 2900 Southern Boulevard, the Bronx

This massive garden and National Historic Landmark is, happily, a fast and direct train ride from Grand Central Terminal. From early March to late April, the Orchid Show, Magnolia Way, and Daffodil Hill are top destinations. The Peggy Rockefeller Rose Garden displays nearly seven hundred varieties of roses, blooming from mid-May through the summer.

Madison Square Park
Between Broadway and Madison Avenue, from East Twenty-Third Street to East Twenty-Sixth Street

Although the park is small, I find that the variety of blooming trees and plants, views of the iconic Empire State and Flatiron Buildings, and winding paths combine to make it a top destination.

Bryant Park
Between Fifth and Sixth Avenues, from West Fortieth Street to West Forty-Second Street

With a distinctive Parisian feel, Bryant Park features games of *boules*, a French-style carousel, and classic bistro tables and chairs. Located next to the main branch of the New York Public Library, it is a much-cherished park in all seasons.

City Hall Park
Between Broadway and Park Row, bounded to the north by Chambers Street

In the heart of the busy downtown area, this leafy oasis is dominated by a majestic fountain and provides a peaceful interlude for city office workers. In April, bright tulips and magnolias herald spring.

The High Line
Between Tenth and Twelfth Avenues, from Gansevoort Street to West Thirty-Fourth Street

The only elevated park in New York City stretches for 1.45 miles (2.33 km) over a disused freight rail line. The plantings re-create the wildflowers and trees that grew naturally while the site was an abandoned urban jungle.

Brooklyn Botanic Garden
Main entrance at 990 Washington Avenue

In addition to numerous specialty gardens and plant collections, the Brooklyn Botanic Garden is justifiably known for its magnificent Cherry Esplanade and its collection of more than two hundred cherry trees, celebrated in the Sakura Matsuri festival in April. The Cranford Rose Garden features cascading arches of blooms and hundreds of varieties of old, modern, species, climber, rambler, and hybrid tea roses.

Prospect Park
Main entrance at Grand Army Plaza, Brooklyn

Located next to the Brooklyn Botanic Garden, the extensive open spaces create a tranquil environment.

FLORAL BOUTIQUES AND STUDIOS

Tin Can Studios
57 Commerce Street, Brooklyn, NY 11231

A full-service floral design studio in Brooklyn's Red Hook neighborhood, founded by Ingrid Carozzi, author of the bestselling flower-arranging book *Handpicked*. Their work features lush, natural, and timeless arrangements and installations, and the studio is a top choice for museum, hotel, and fashion clients.

Flower Girl
245 Eldridge Street, New York, NY 10002

Flower Girl is known for beautiful, edgy, and delightful arrangements that focus on seasonal flowers representing the changing moods of New York.

Bastille Boutique
Chelsea Market, 75 Ninth Avenue, New York, NY 10011

This is the boutique of floral design studio Bastille Flowers & Events, known for extravagant installations and magical weddings. Here they offer a luscious selection of bouquets and cut flowers. Choose a vase, and their creative designers will fashion a custom arrangement as a special gift or to grace your hotel room.

University Floral Design
51 University Place, New York, NY 10003

This pretty corner flower shop near New York University reminds me more than any other in New York City of the elegant flower shops in Paris. It has lovely displays, helpful staff, and abundant choices of gorgeous fresh flowers, especially roses and seasonal blooms.

L'Olivier Floral Atelier
19 East Seventy-Sixth Street, New York, NY 10021

The arrangements of this premier luxury florist grace the homes and offices of celebrities in New York's fashion and arts communities, but their petite boutique, tucked away on the Upper East Side, is a reliable destination for even a simple bouquet, guaranteed to dazzle with the most exquisite flowers.

Eli's Market Flowers
1411 Third Avenue, New York, NY 10028

This tiny jewel box of a shop is literally bursting with gorgeous blooms, stacked on tables, overflowing from urns, and lined up on the street corner. Step inside and be enveloped in petals and fragrance while you choose a custom bouquet or potted spring bulbs.

FlowerSchool New York
213 West Fourteenth Street, New York, NY 10011

The school offers a wide range of individual classes and comprehensive courses in floristry and design. The instructors include the top tier of New York floral professionals.

Putnam & Putnam
120 West Twenty-Eighth Street, New York, NY 10001

Renowned for their arrangements and installations inspired by still-life paintings, they also regularly offer themed one-day workshops.

MARKET FLOWERS

New York City Wholesale Flower Market
West Twenty-Eighth Street between Sixth and Seventh Avenues

I've spent many happy hours on this block, purchasing flowers, marveling at the displays, and observing the reactions of passersby to the veritable flower carpet laid out on the sidewalks. Arrive early, before 7:00 A.M., for the best selection. Many of the vendors are wholesale only, but quite a few also sell to the public. Well worth a visit in any season.

Union Square Greenmarket
North and west sides of Union Square

The city's largest and liveliest outdoor market is a great destination for plants, fresh bouquets, cut flowers, and annuals—many sold directly by the growers. Open Mondays, Wednesdays, Fridays, and Saturdays year-round. Bring cash for most purchases from local vendors.

Grand Army Plaza Greenmarket
Grand Army Plaza, at the northwest corner of Prospect Park, Brooklyn

Open Saturdays year-round, the borough's flagship greenmarket, located near the main branch of the Brooklyn Public Library and the Brooklyn Botanic Garden, offers potted plants and cut flowers in season.

79th Street Greenmarket
Columbus Avenue between West Seventy-Seventh and West Eighty-First Streets

Located along the west side of the American Museum of Natural History. Go on a Sunday morning to choose fresh flowers or potted flowering plants after visiting this remarkable museum.

INDEX OF PHOTOGRAPHS

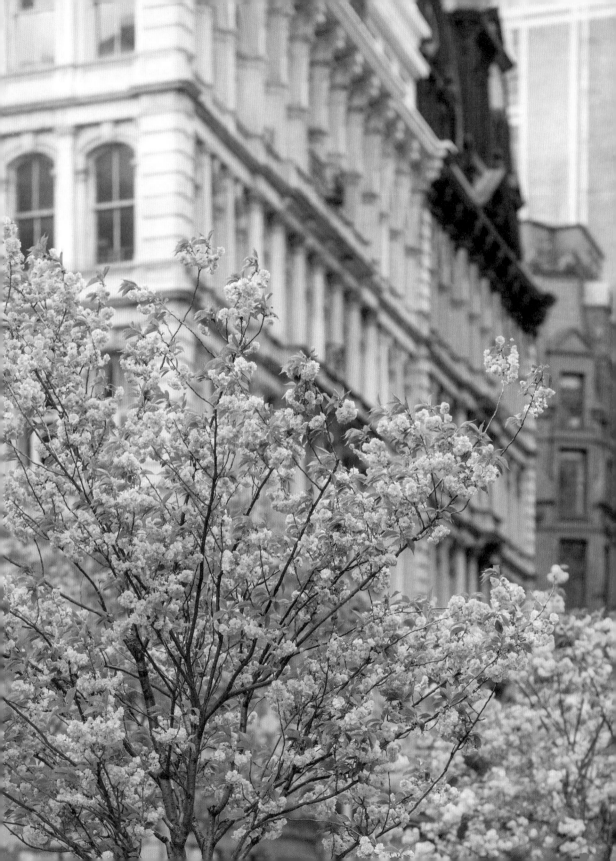

DEDICATION

To the residents of New York City, past, present and future. May you always be in bloom.

ACKNOWLEDGMENTS

Immersing myself in the floral culture and heritage of New York City has been a privilege, as is the opportunity to share my discoveries through this book. My heartfelt gratitude and admiration to the many individuals and organizations without whom this work would not have been possible:

My wonderful agent Kate Woodrow for understanding my passions and dreams, and guiding them to reality.

My brilliant and patient editor, Laura Dozier, and masterful designer Darilyn Carnes, at Abrams for their expertise and unfailing enthusiasm in bringing this project to the world.

The exceptionally creative Nim Ben-Reuven for once again elevating the entire presentation with his magnificent calligraphy.

The Office of the Mayor of New York City, the New York City Department of Parks and Recreation, and the Central Park Conservancy for their dedication to the continual improvement of the quality of life for all New York City residents and visitors by championing the city's many parks, gardens, and green spaces, which feature so prominently here.

The Metropolitan Museum of Art, whose groundbreaking and generous Open Access policy grants unrestricted use of images of hundreds of thousands of public-domain works in its collections, including several key works used in this book.

The Brooklyn Botanic Garden for creating a spectacular urban botanic garden and allowing me early entrance to capture images of the romantic Cranford Rose Garden at peak bloom.

The New York Botanical Garden for arranging my special access to photograph their spectacular collections, including Daffodil Hill and the Peggy Rockefeller Rose Garden.

The Bryant Park Corporation and the Madison Square Park Conservancy for the opportunity to photograph and feature their splendid parks.

The Morgan Library & Museum for permission to feature one of their exquisite doors.

The Plaza Hotel for allowing me to photograph and feature their superb lobby floral displays.

The St. Regis New York for permission to feature their stunning lobby florals and glorious ceiling painting.

The JW Marriott Essex House New York for permission to feature their marvelous Art Deco elevator doors.

Iconic New York institutions Rockefeller Center and Macy's Herald Square for their extravagant spring floral displays and for enabling me to feature them.

Floral studios University Floral Design, Bastille Flowers & Events, Emily Thompson Flowers, and Flower Girl for allowing me to feature images of their locations.

The floral wholesalers on West Twenty-Eighth Street who welcomed me on many early mornings, including G. Page Wholesale Flowers, Dutch Flower Line, and J. Rose Wholesale Flowers.

The owners of the world-famous pizzeria John's of Times Square for allowing me to feature their breathtaking stained-glass ceiling.

Floral designer Ingrid Carozzi, owner of Tin Can Studios and author of the bestselling *Handpicked*, for creating many of the elegant florals in the Floral Studios chapter and in the step-by-step project in the appendix.

Morgane Sézalory, founder of L'Appartement Sézane on Elizabeth Street, for use of the image of the boutique's colorful floral decor featured in the book.

Maya Hormis, founder of Bon Vivant New York, for creating the beautiful petits fours.

Artists Natasha May Platt and Gabriella Diana for graciously allowing me to photograph their joyful floral mural, and to fashion designer Yumi Kim for the fabric pattern that inspired it.

Artist Damon Johnson (@damonnyc) for his gorgeous rose mural which I am thrilled to showcase.

Valued friends and New York City residents who contributed their time and knowledge for photoshoots and location scouting: Elena Polshakov, Jackie Quan, Jacqueline Clair, and Deann Arce.

My family and my husband, David, for their endless patience and support for my extensive globe-trotting and deadline-driven lifestyle.

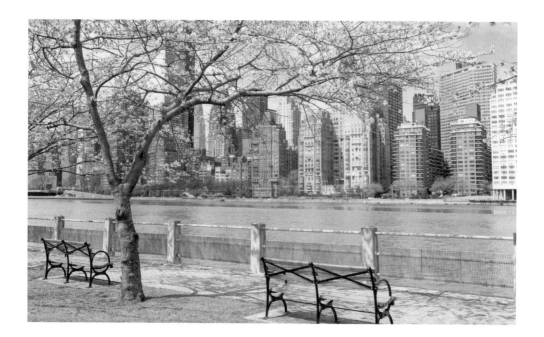

Editor: Laura Dozier
Designer: Darilyn Lowe Carnes
Production Manager: Michael Kaserkie

Library of Congress Control Number: 2018936287

ISBN: 978-1-4197-3079-5
eISBN: 978-1-68335-493-2

Printed and bound in China
10 9 8 7 6 5 4 3 2 1

Abrams Image books are available at special discounts when purchased in quantity for premiums
and promotions as well as fundraising or educational use. Special editions can also be created to
specification. For details, contact specialsales@abramsbooks.com or the address below.

ABRAMS The Art of Books
195 Broadway, New York, NY 10007
abramsbooks.com